Mike's Mind Bending Coloring Book

Mike F. Capshaw

Copyright © 2017 Mike Capshaw

All rights reserved.

ISBN: 1544875215

ISBN-13: 978-1544875217

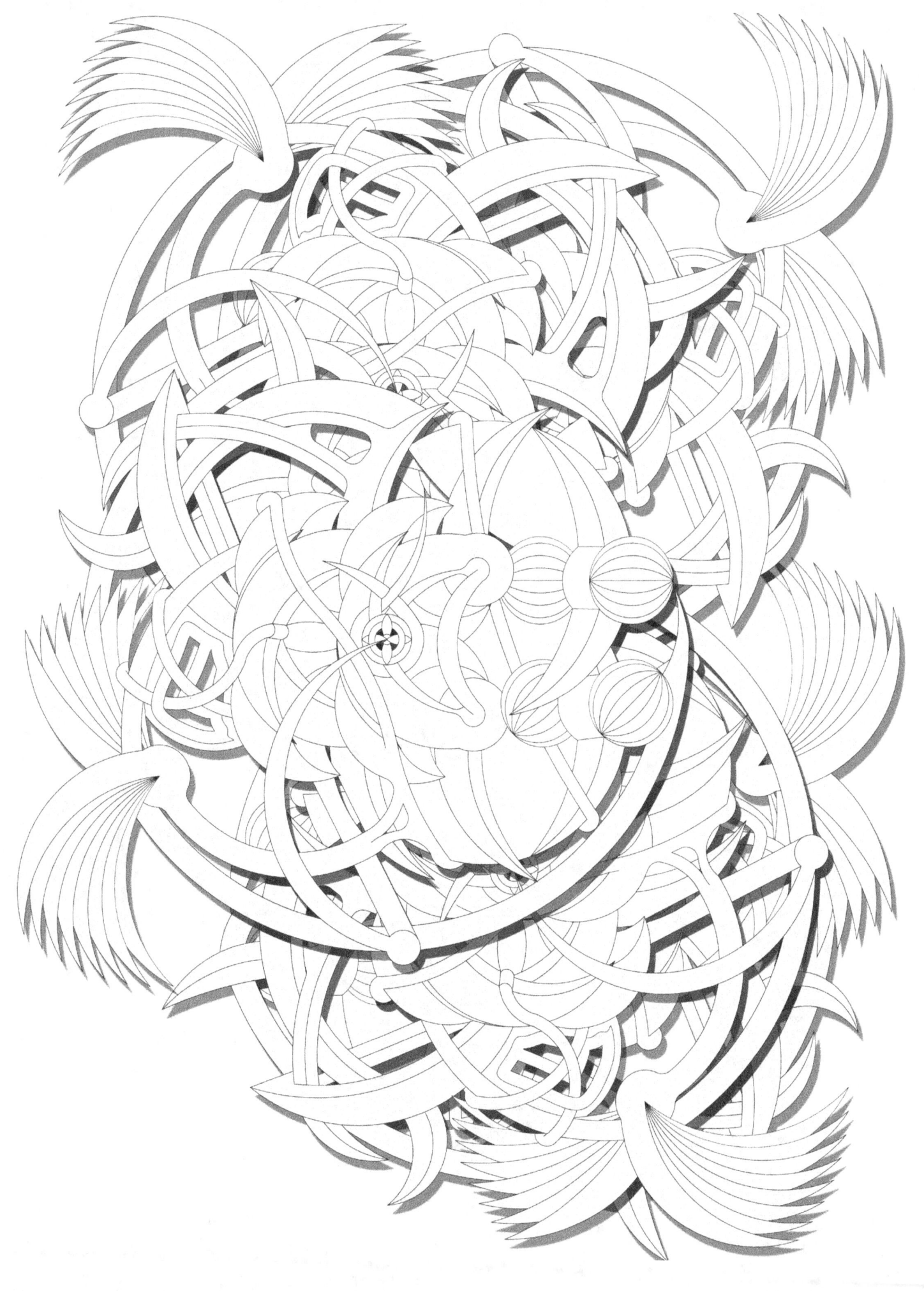

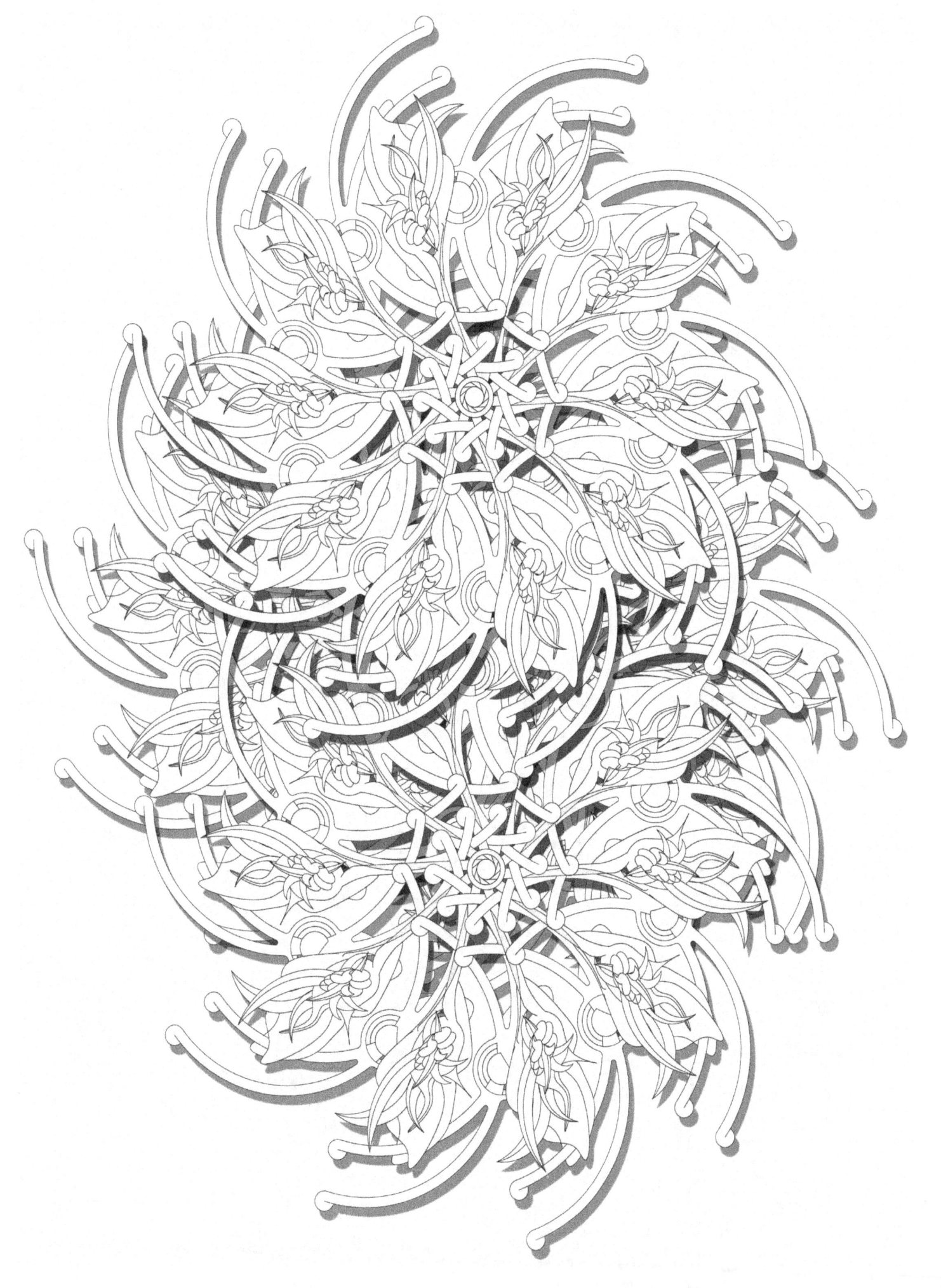

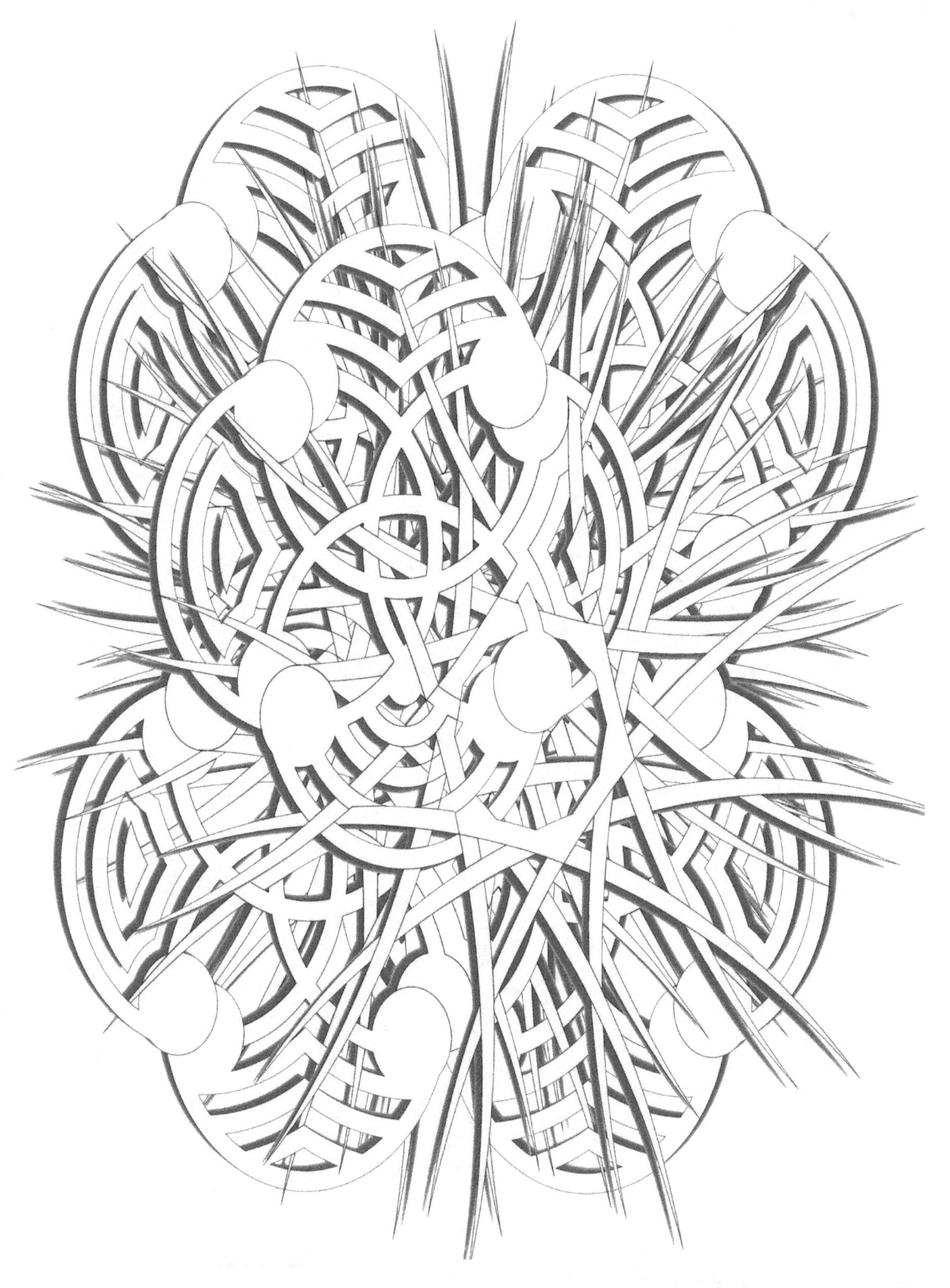

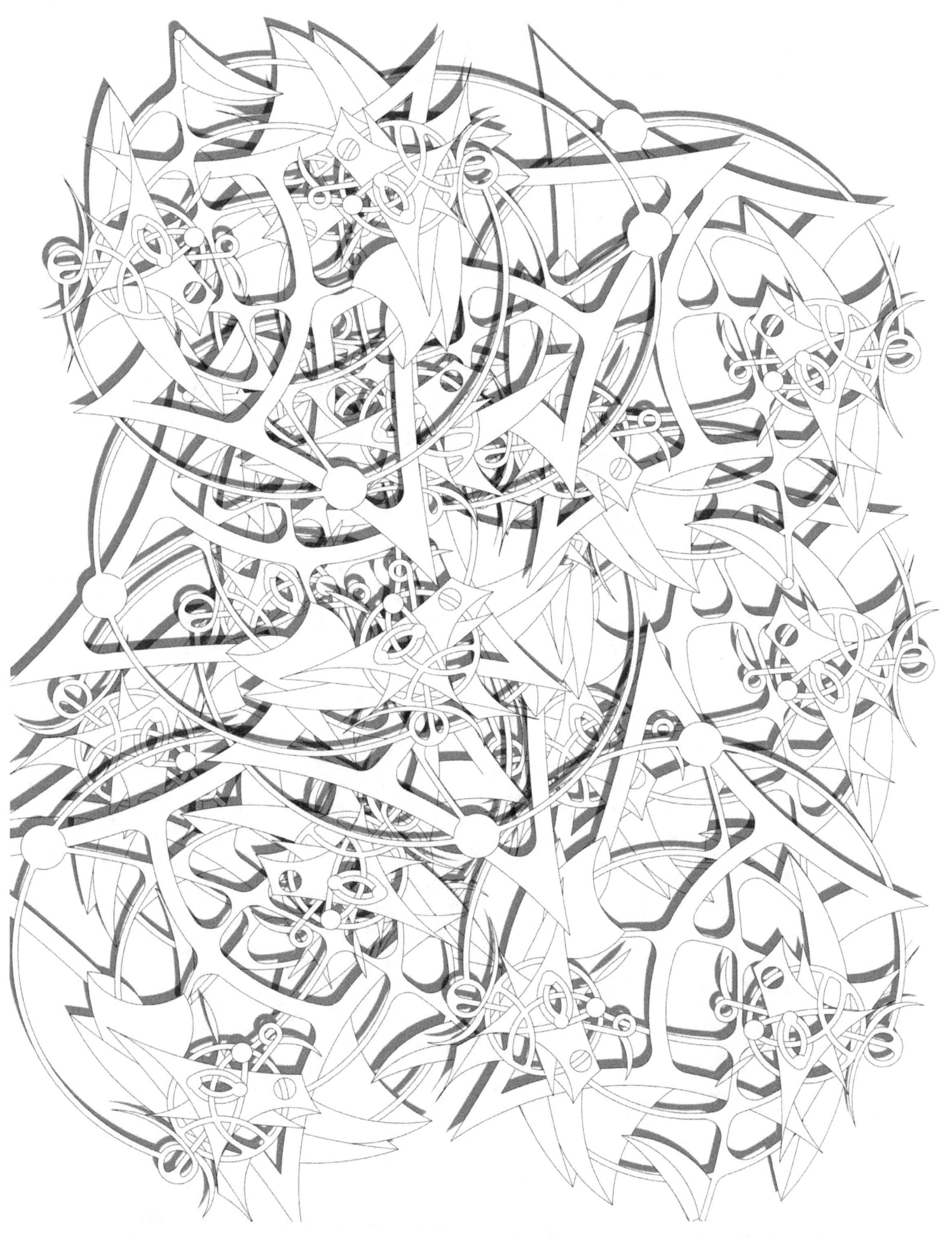

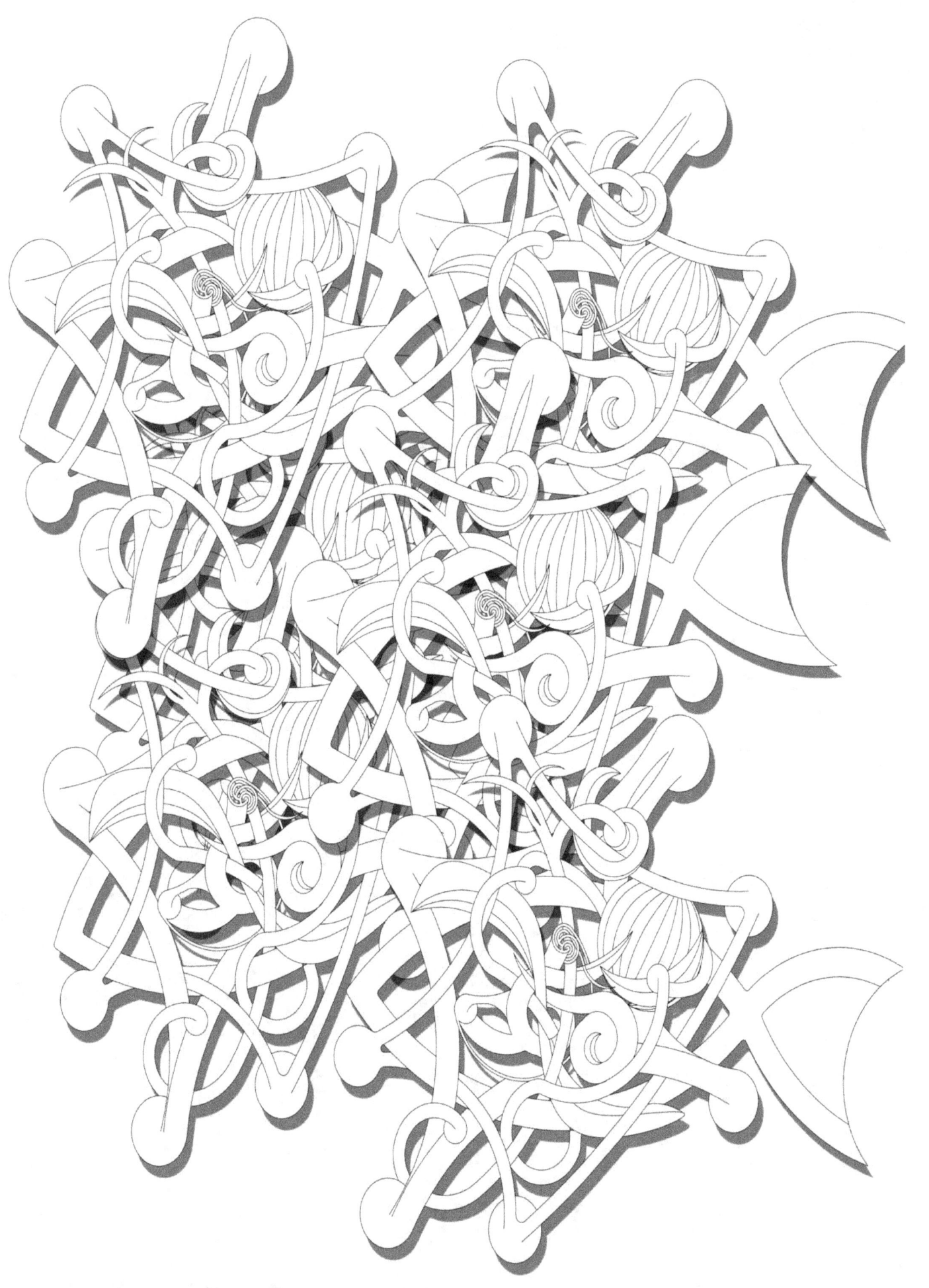

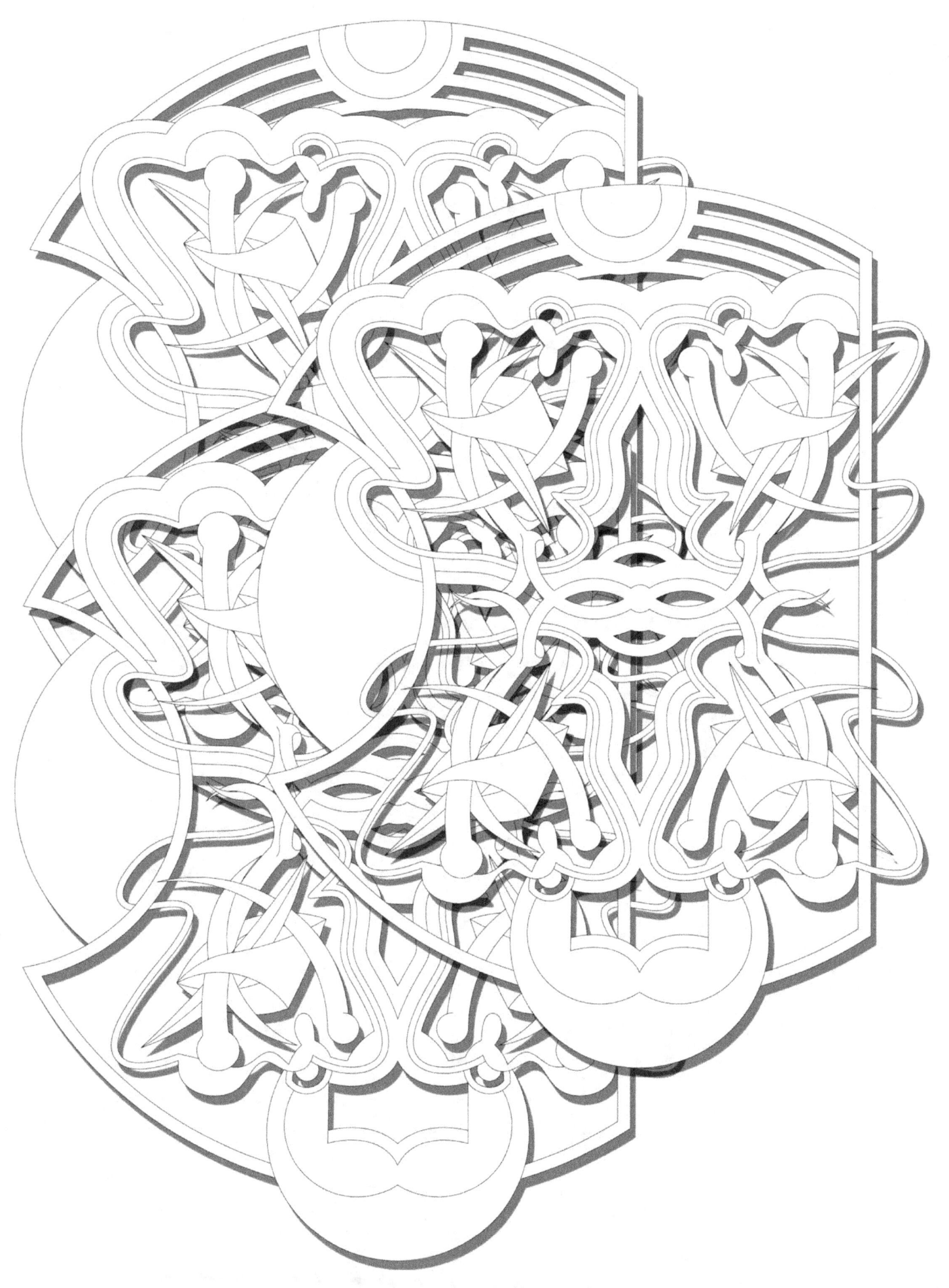

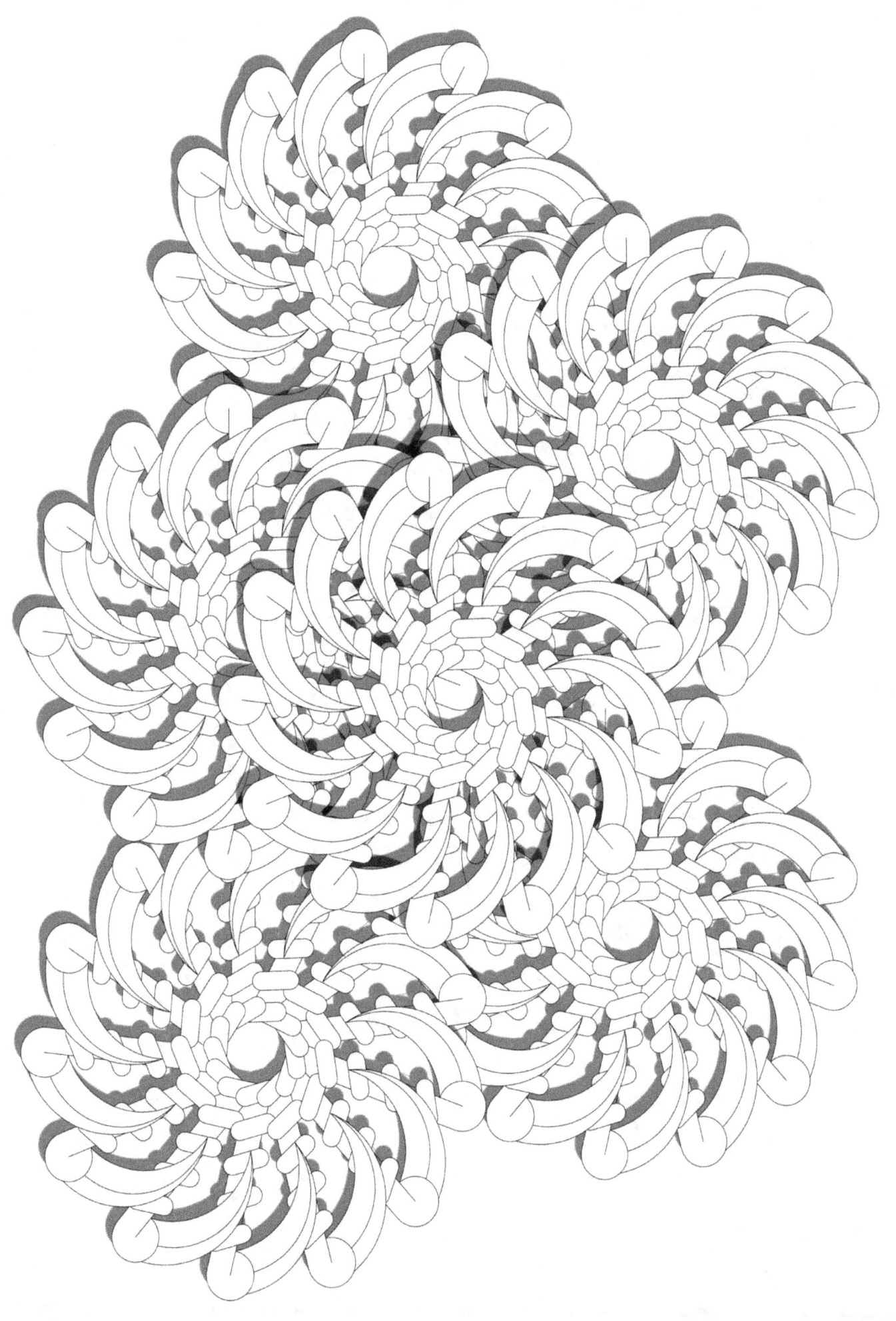

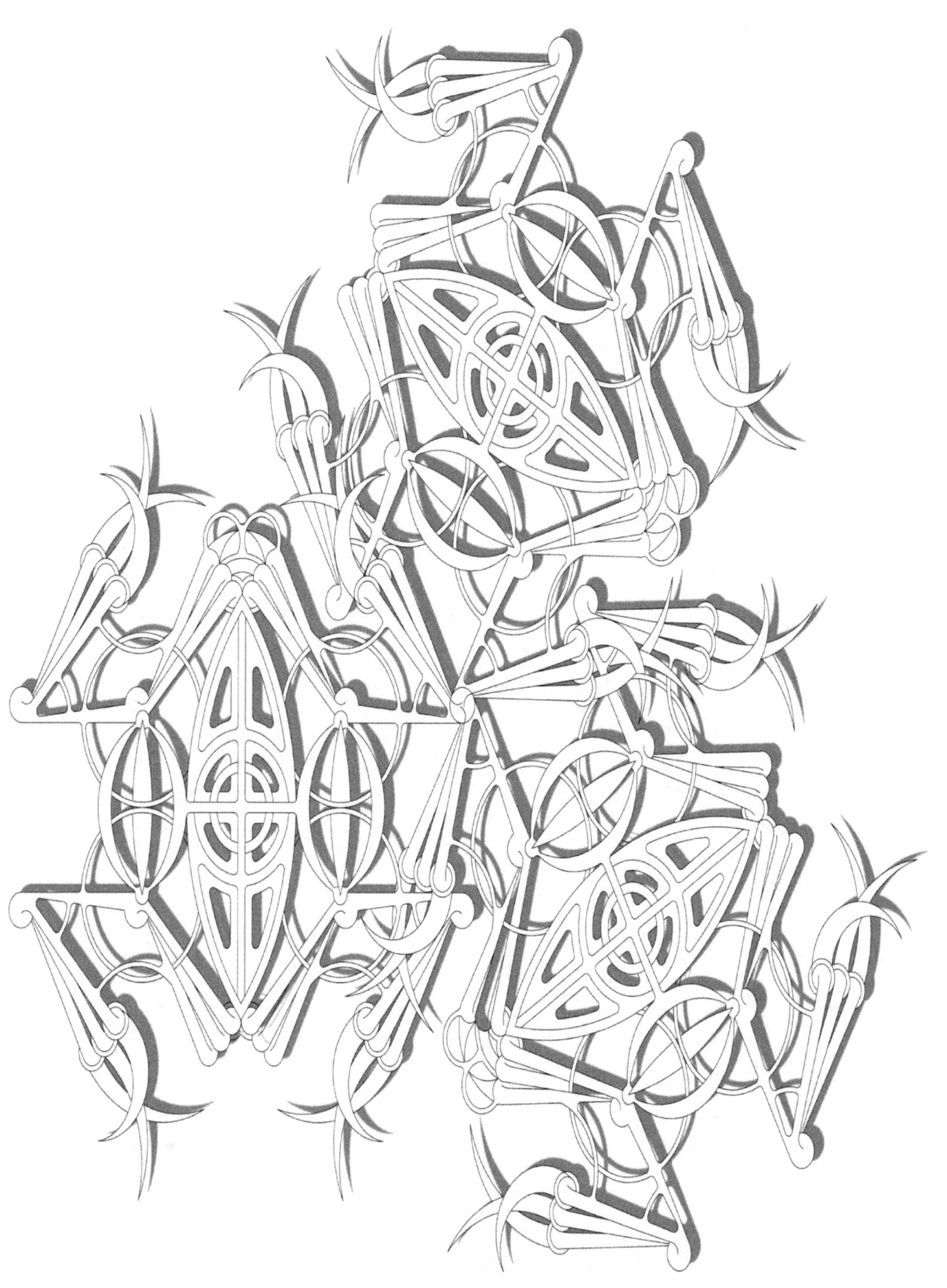

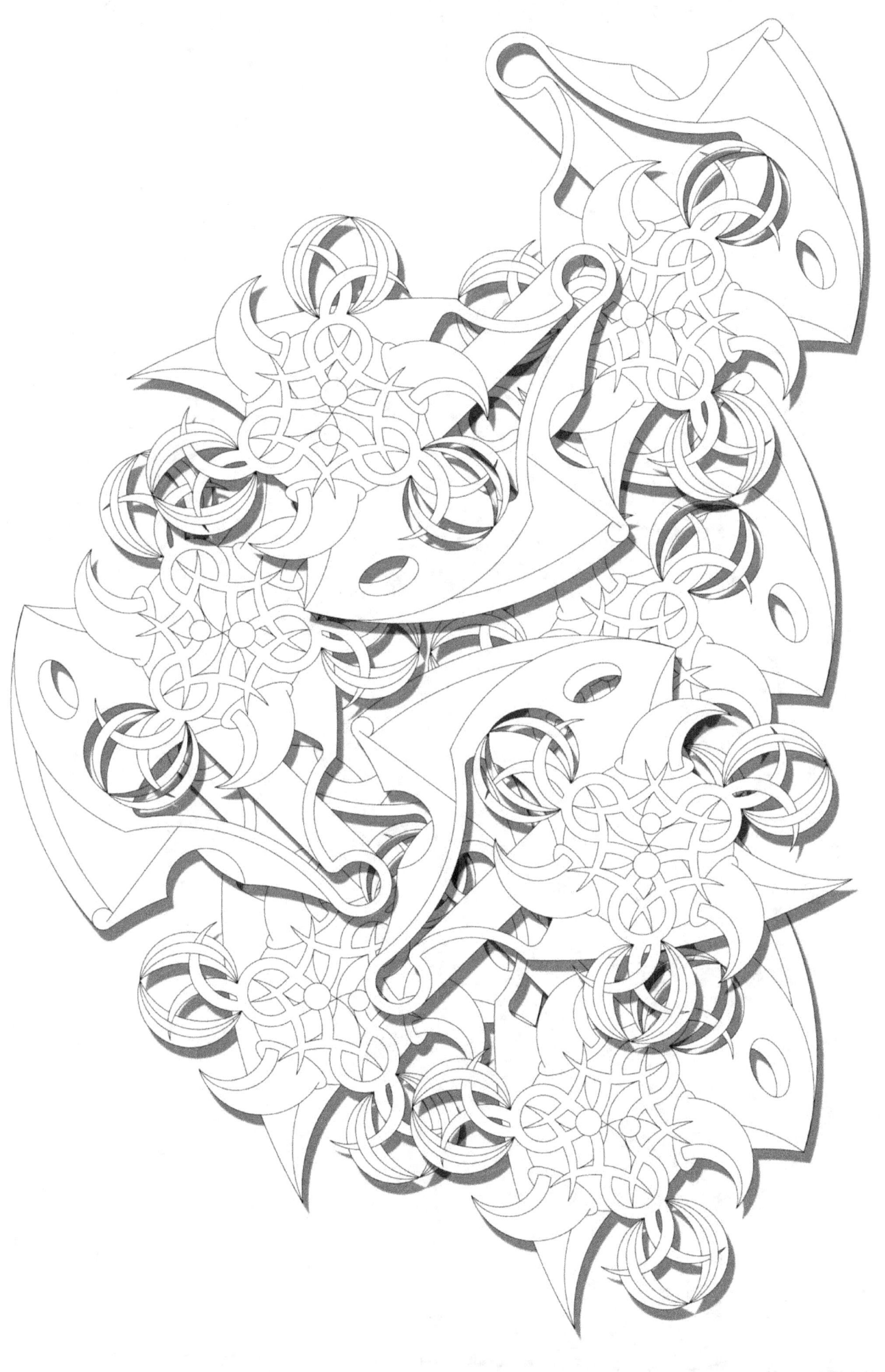

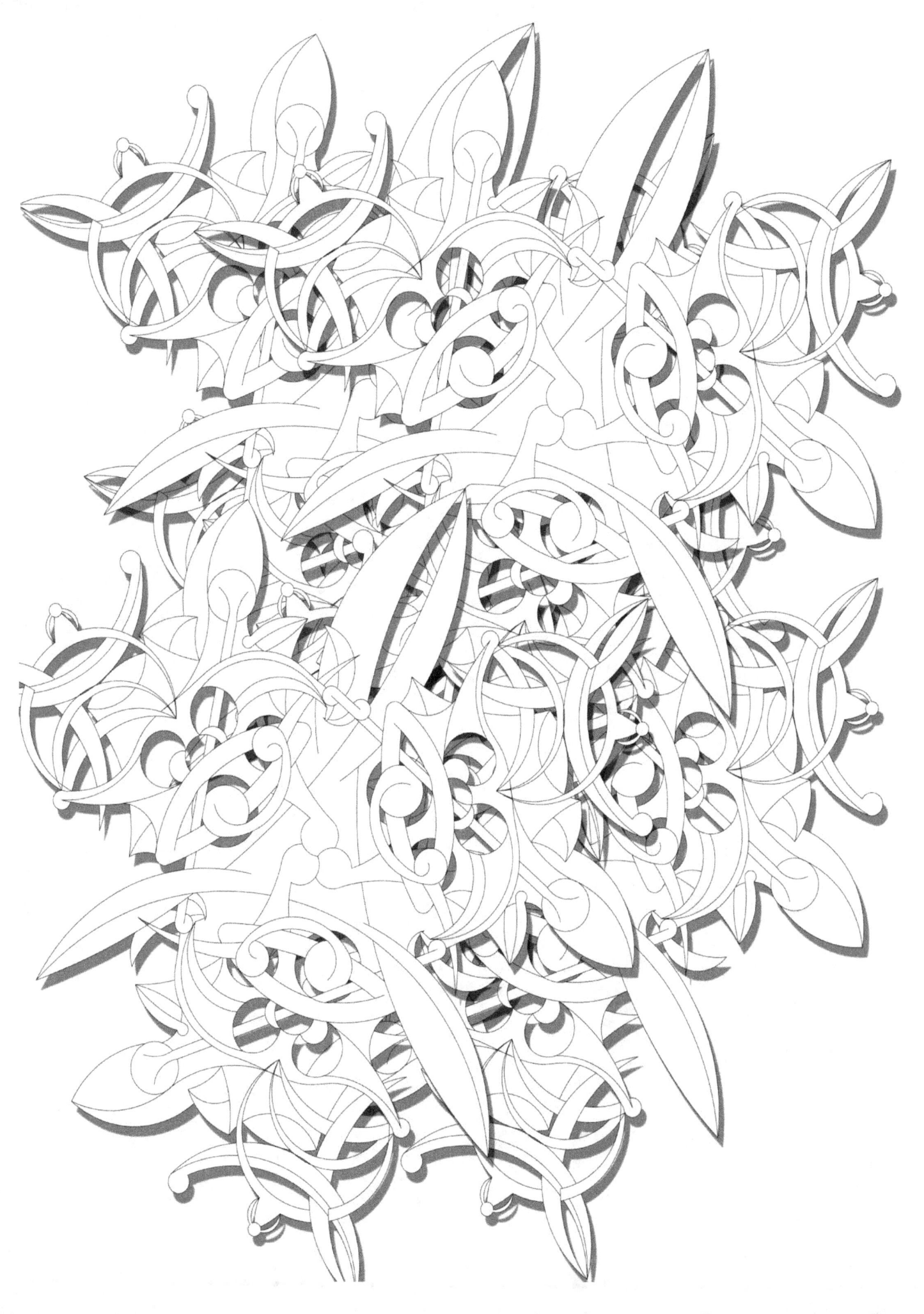

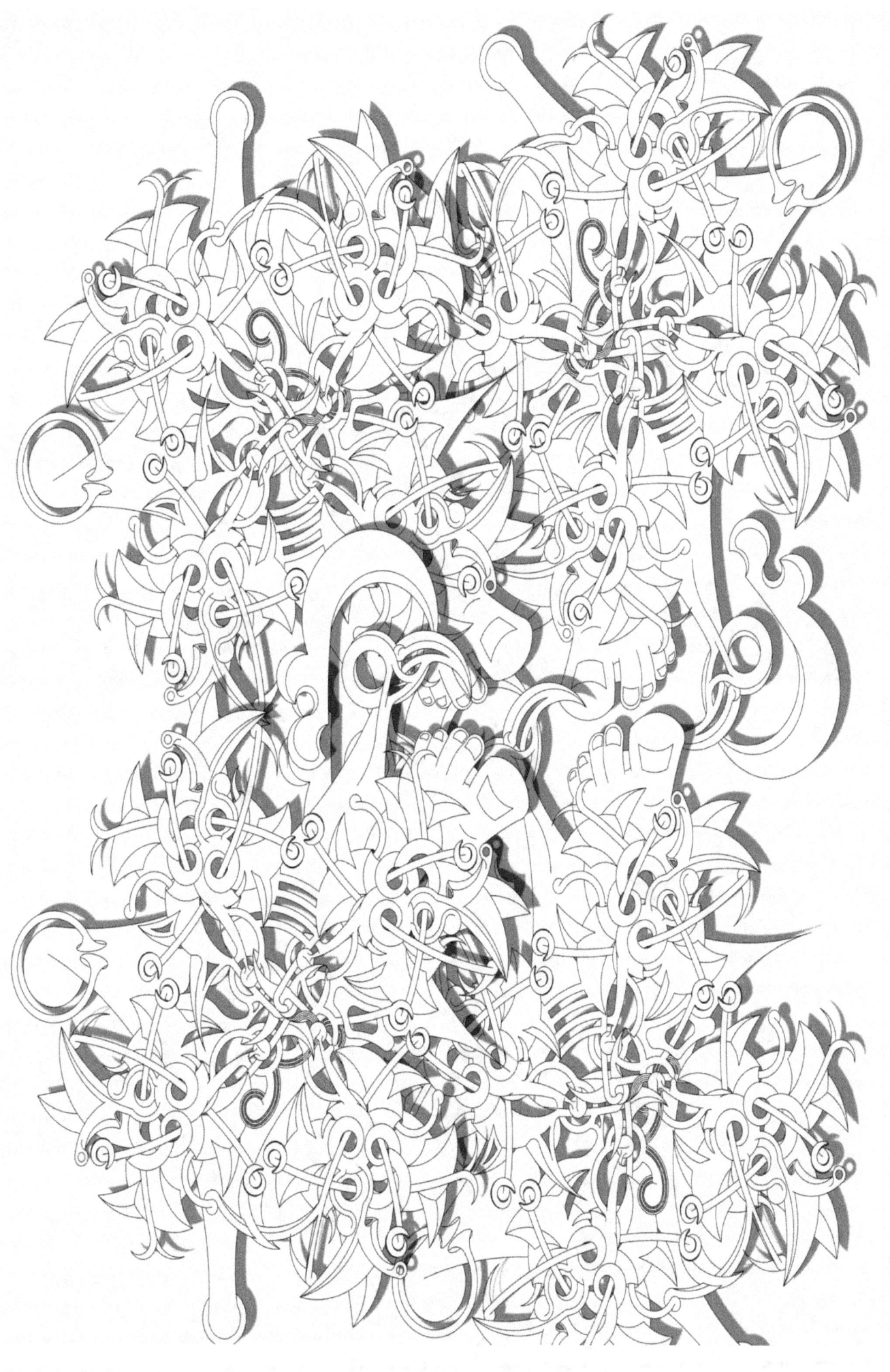

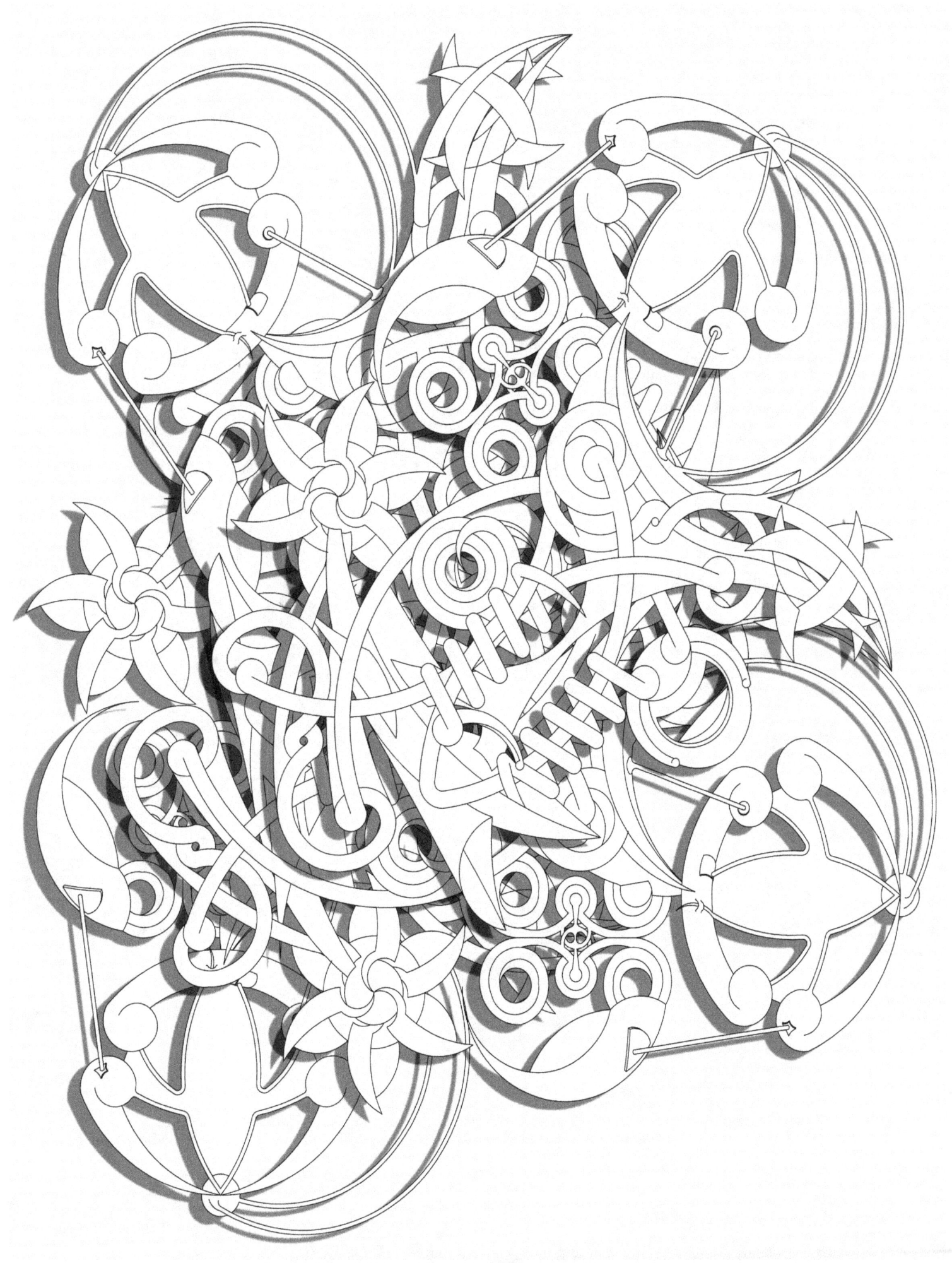

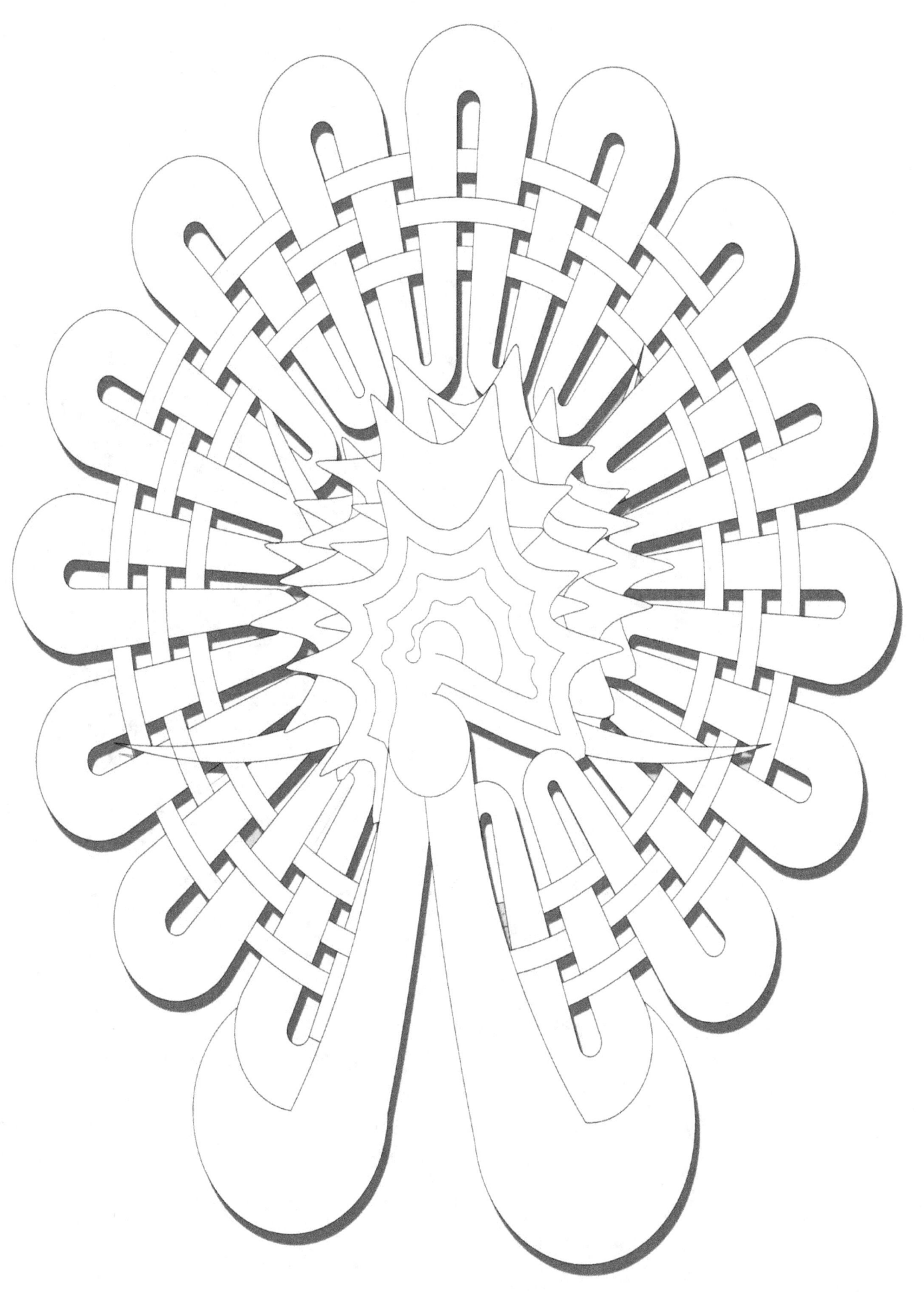

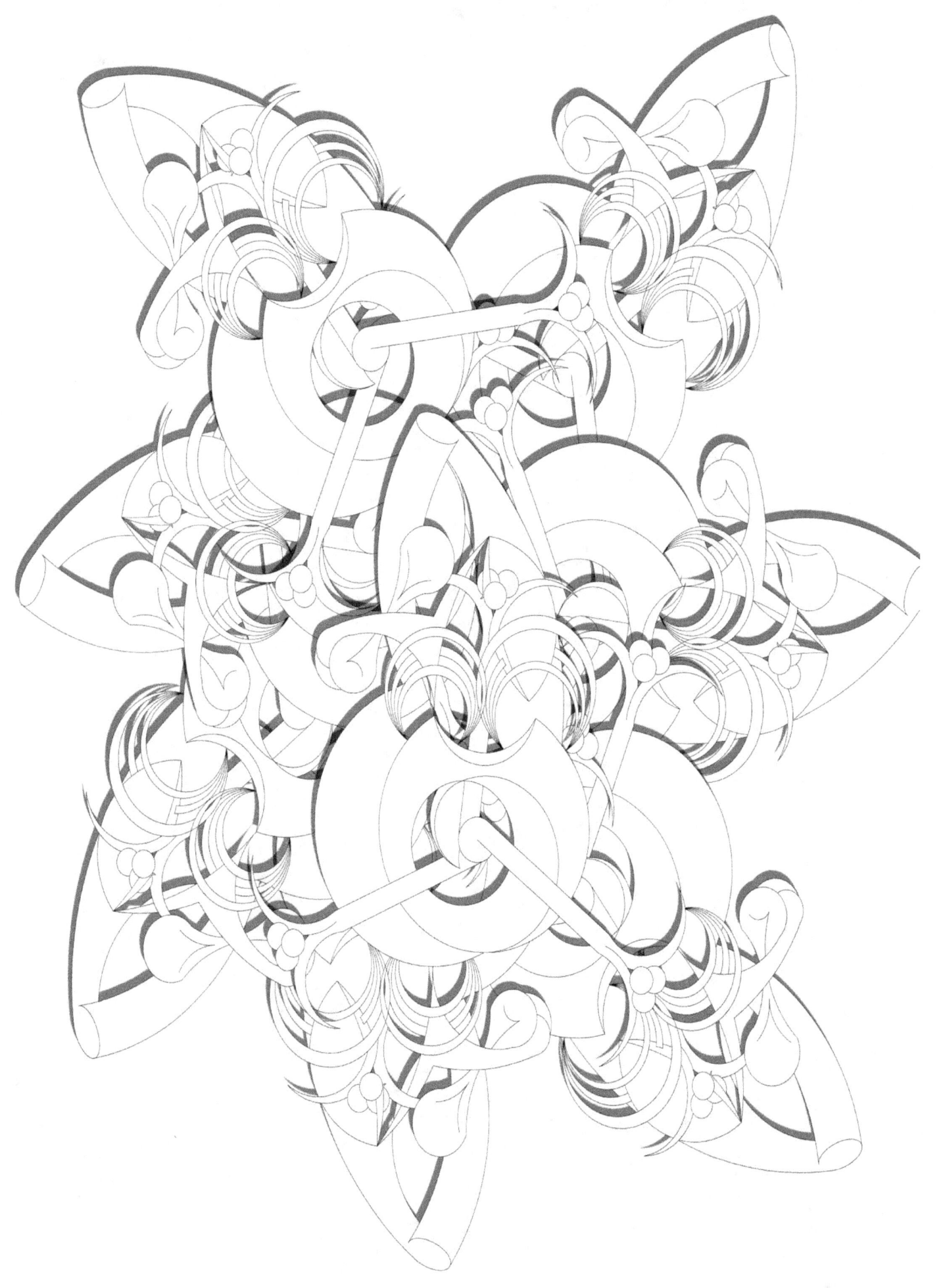

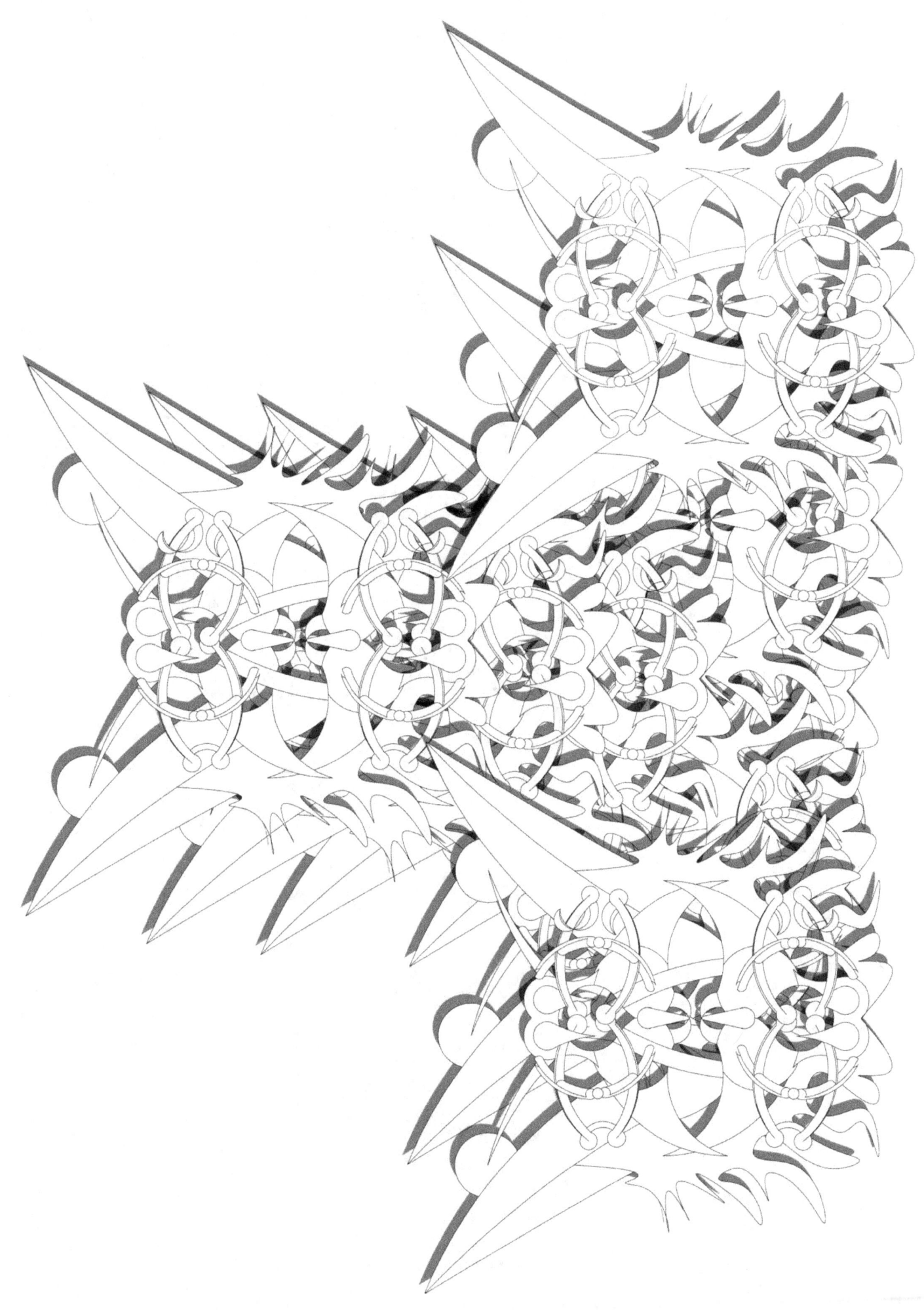

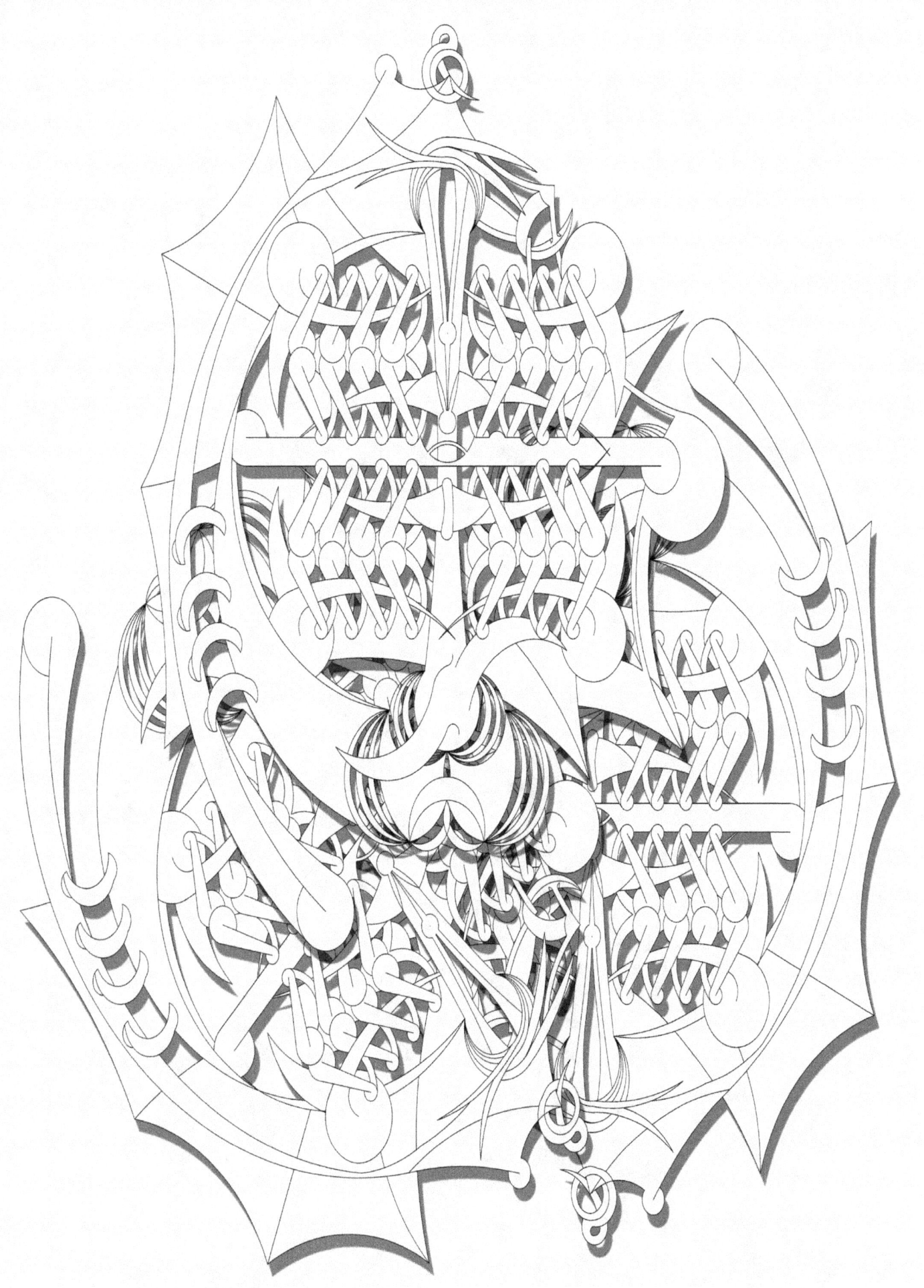

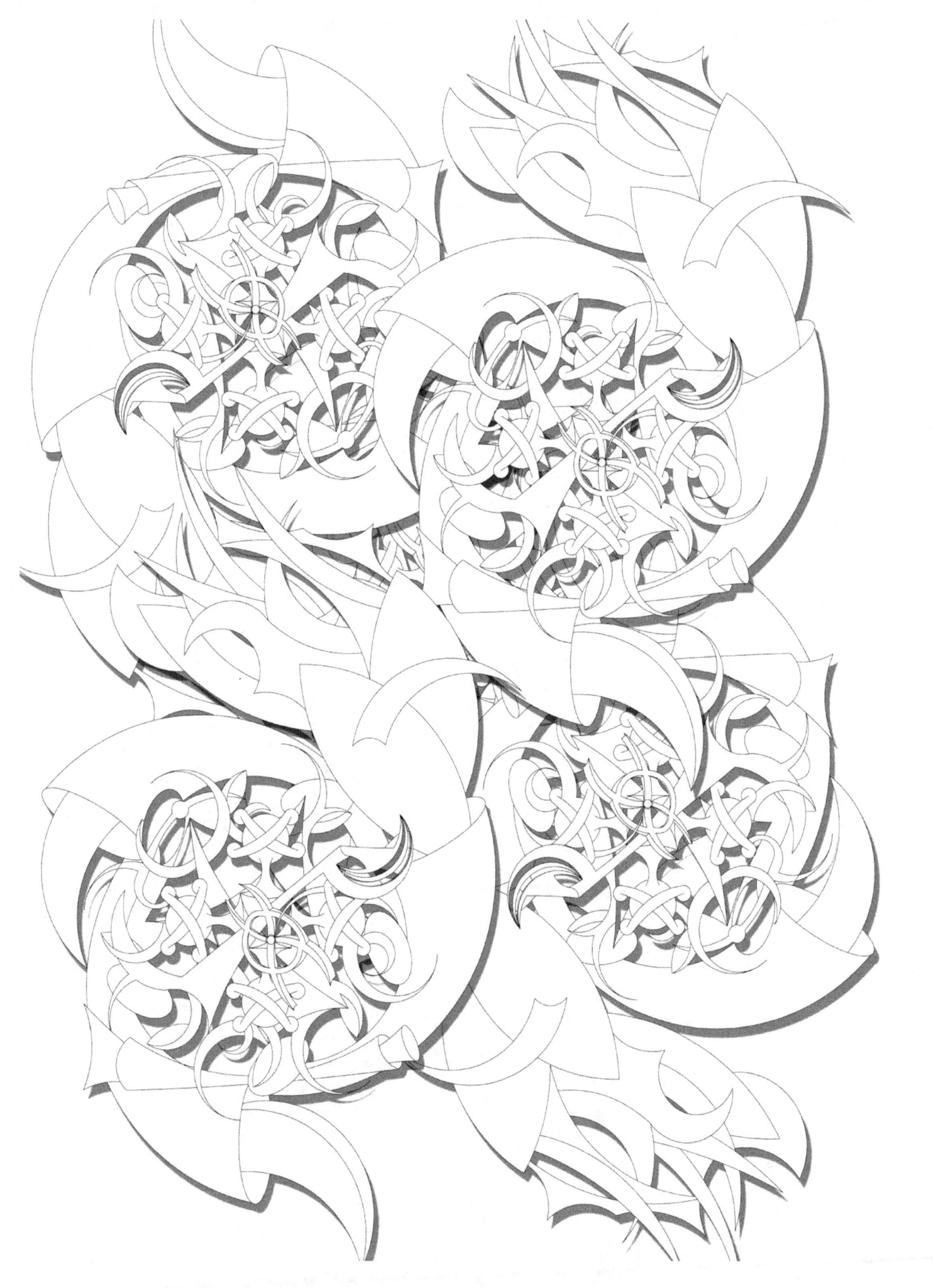

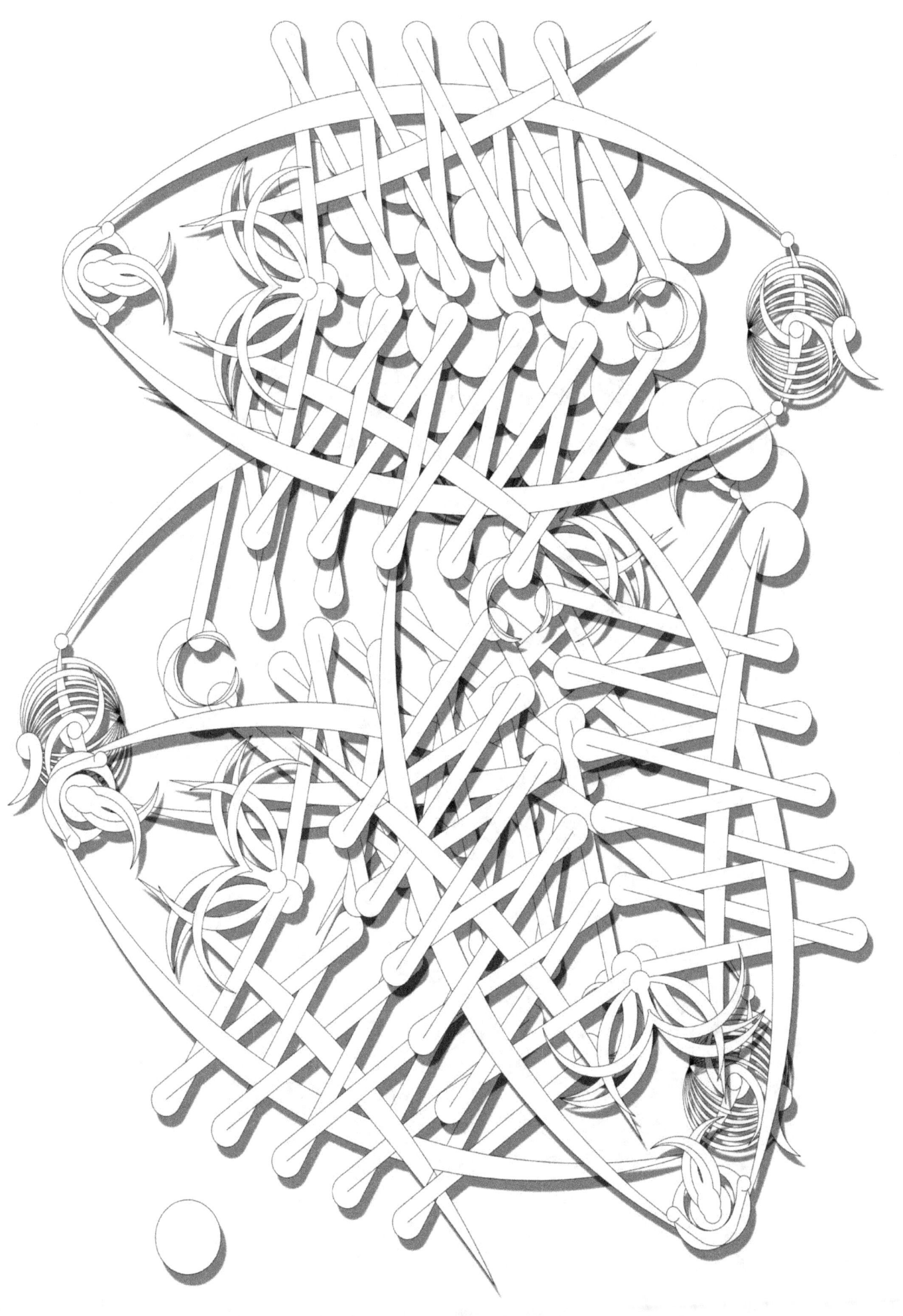

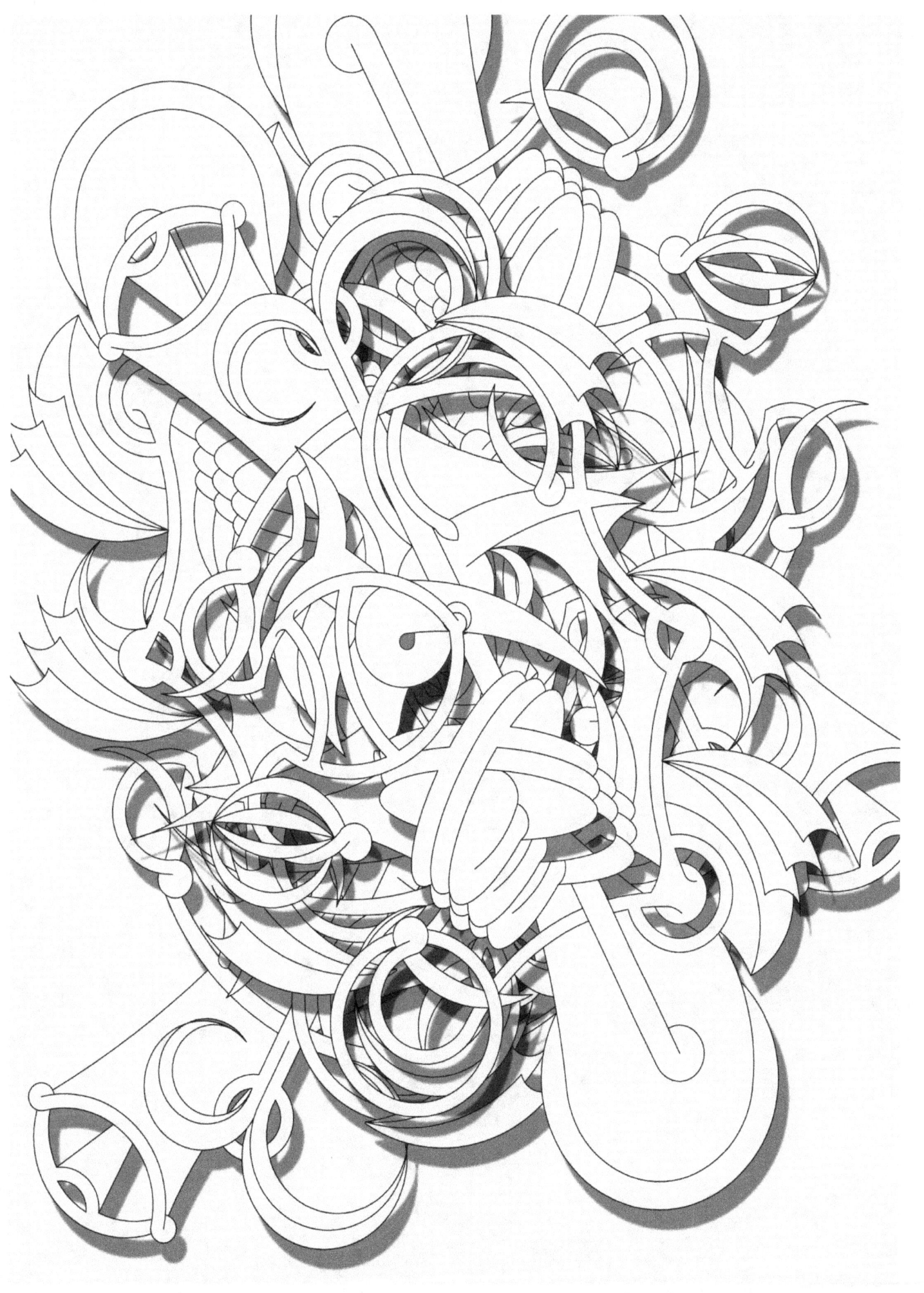

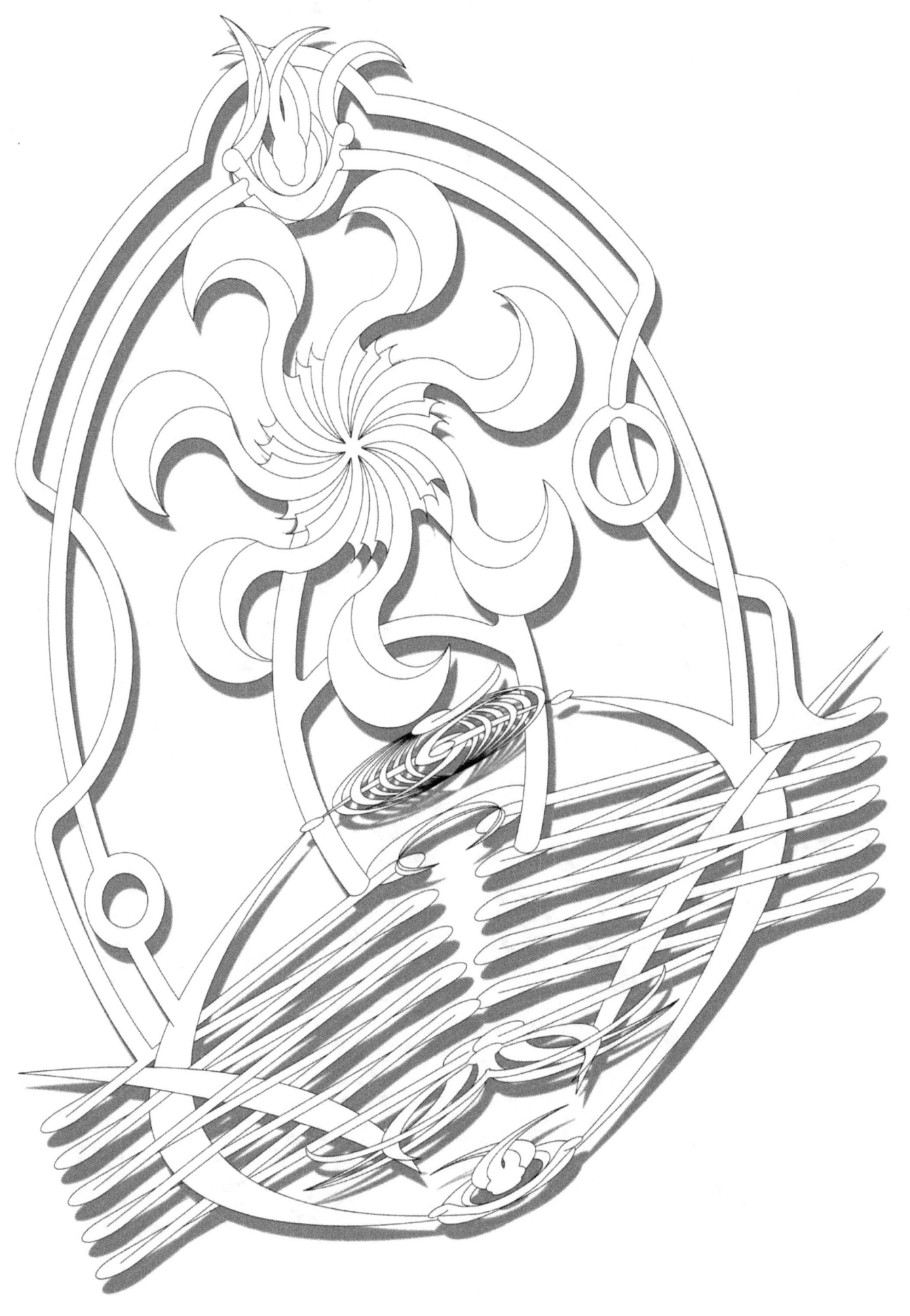

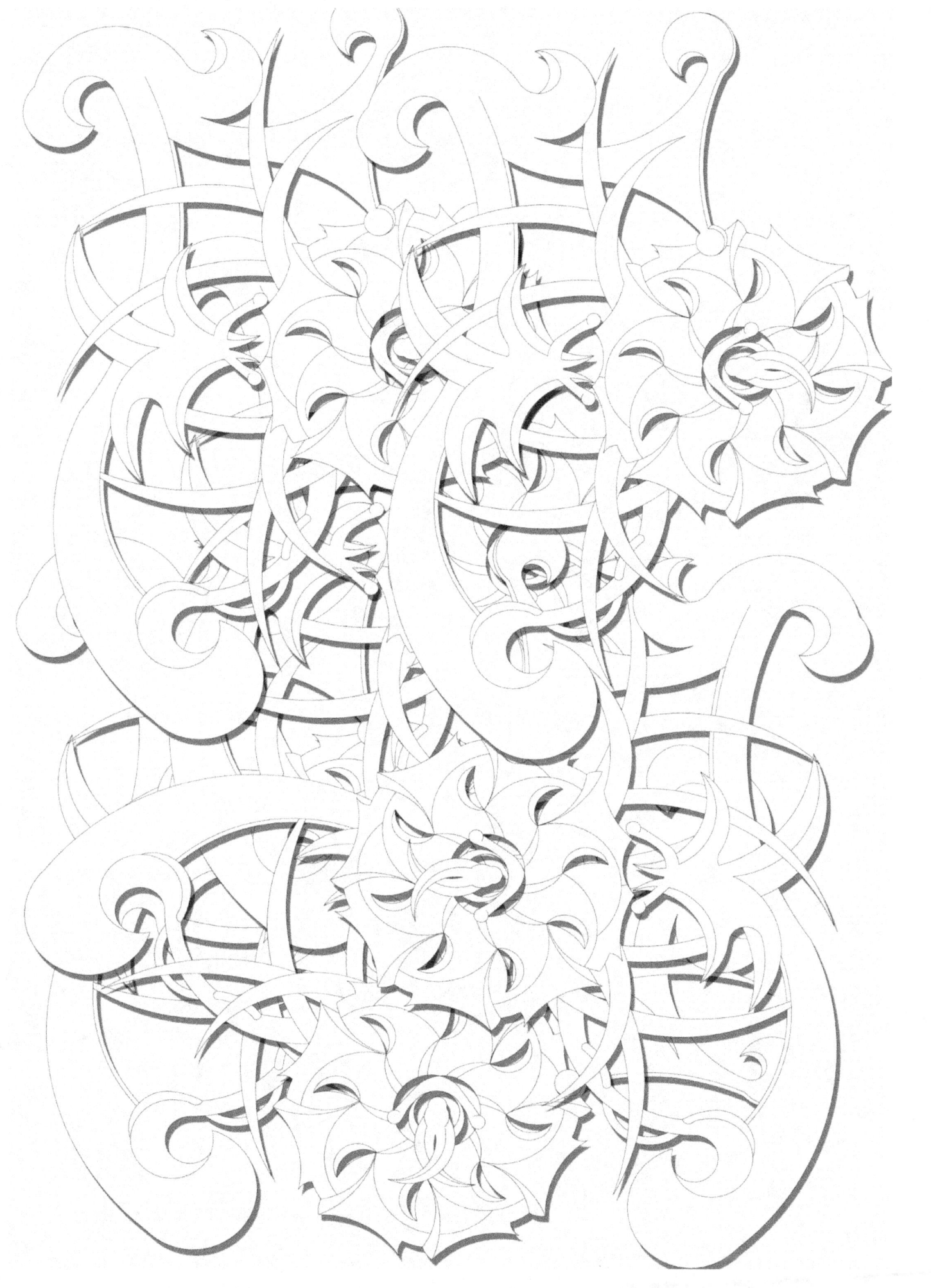

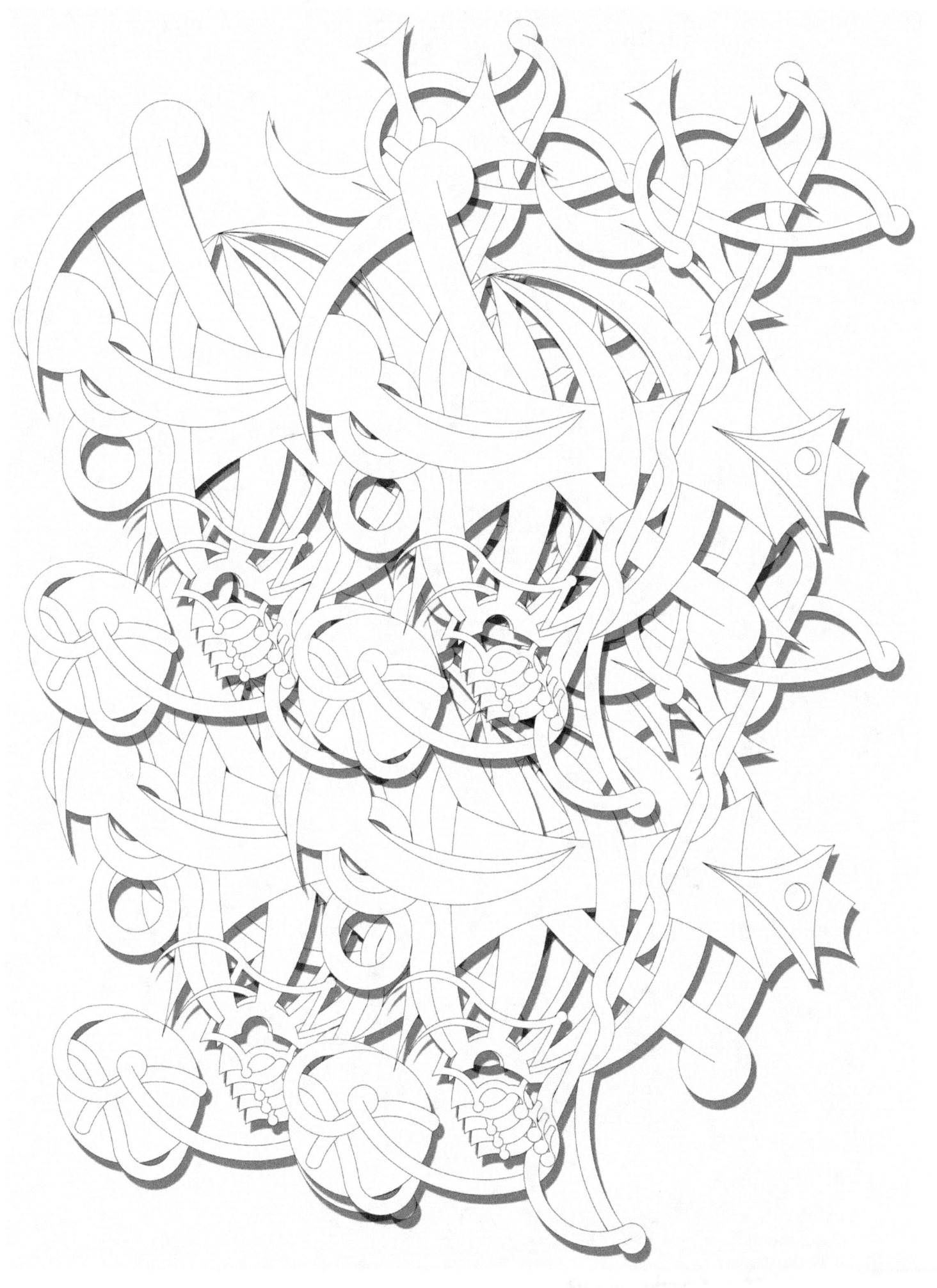

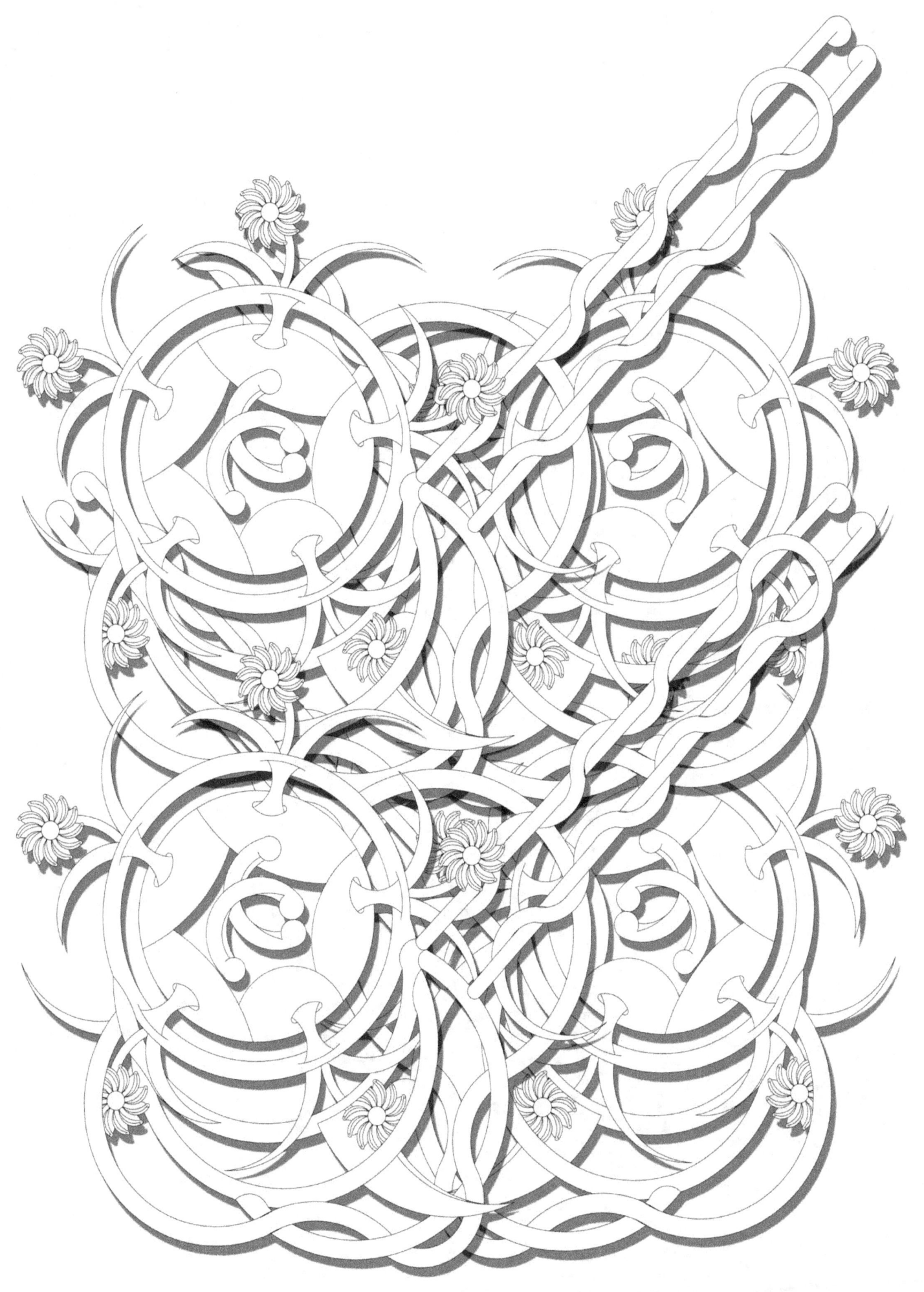

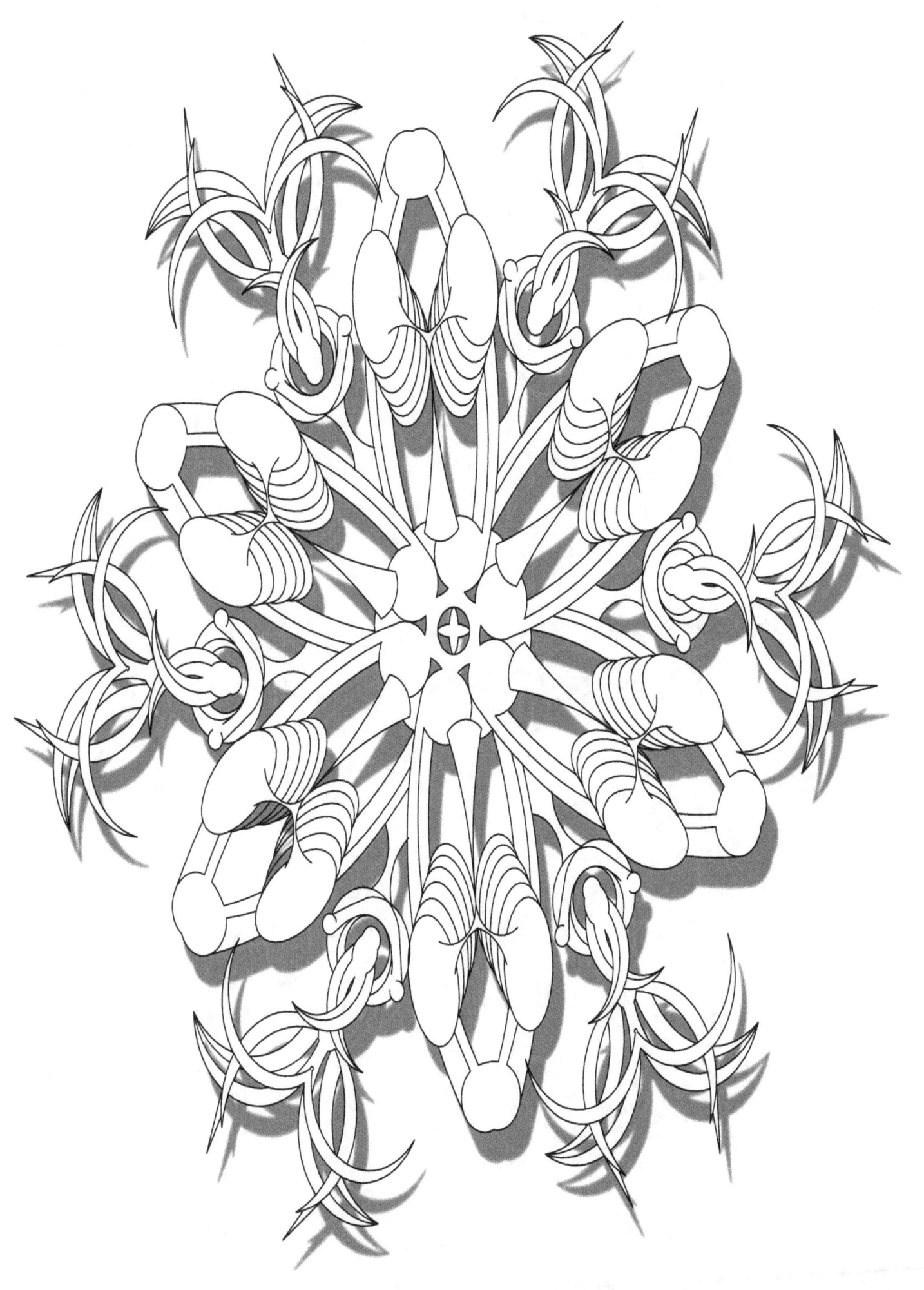

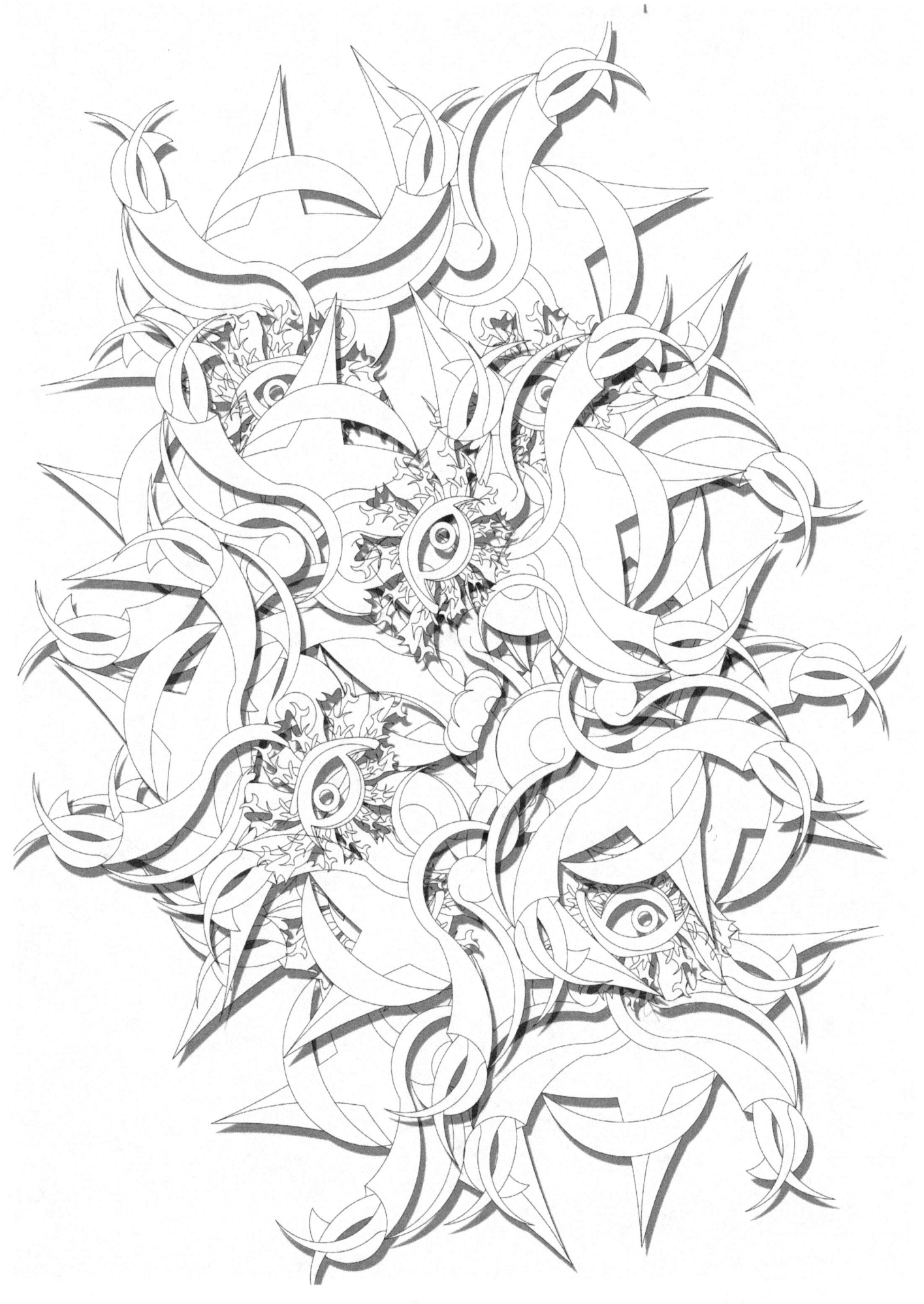

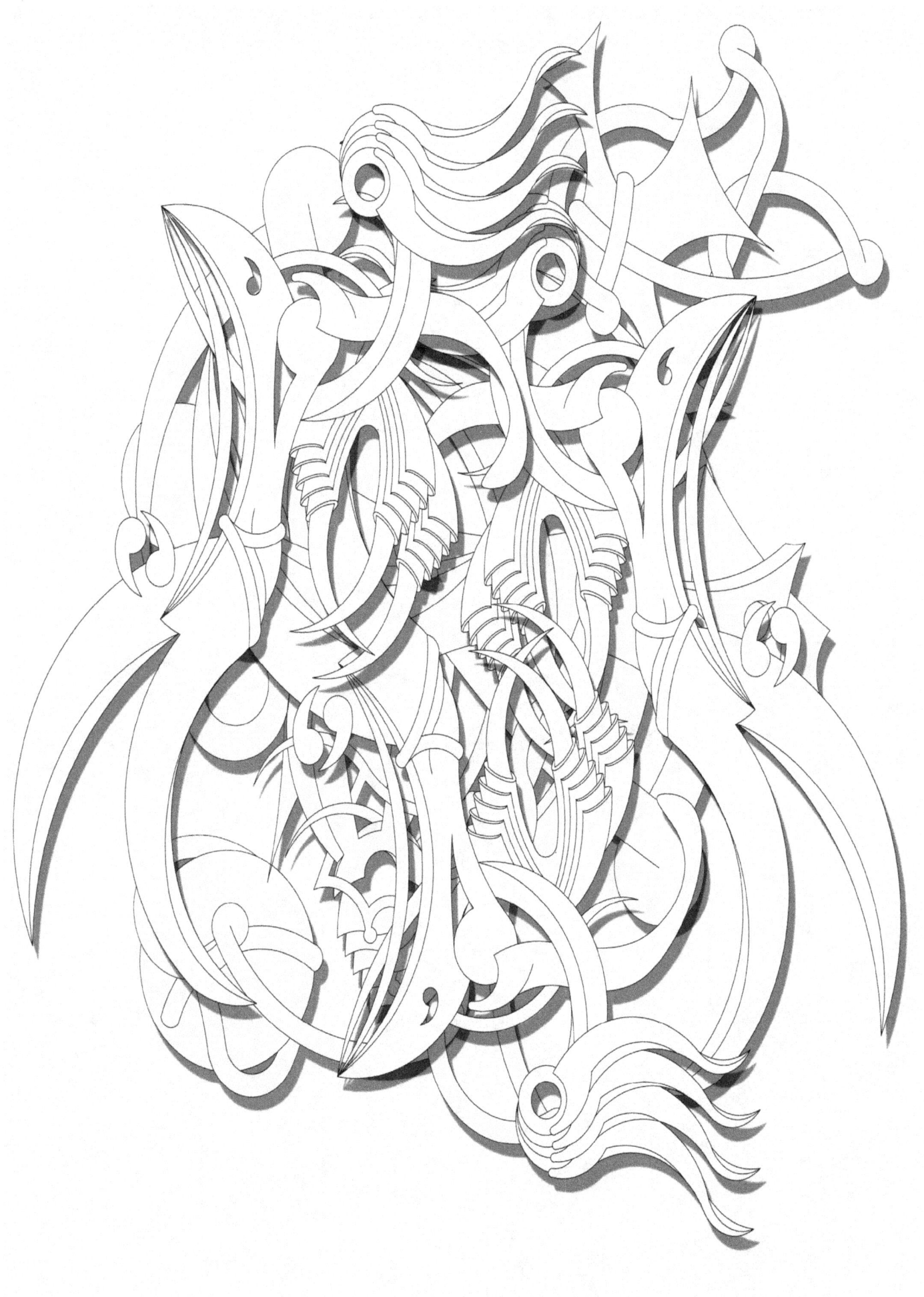

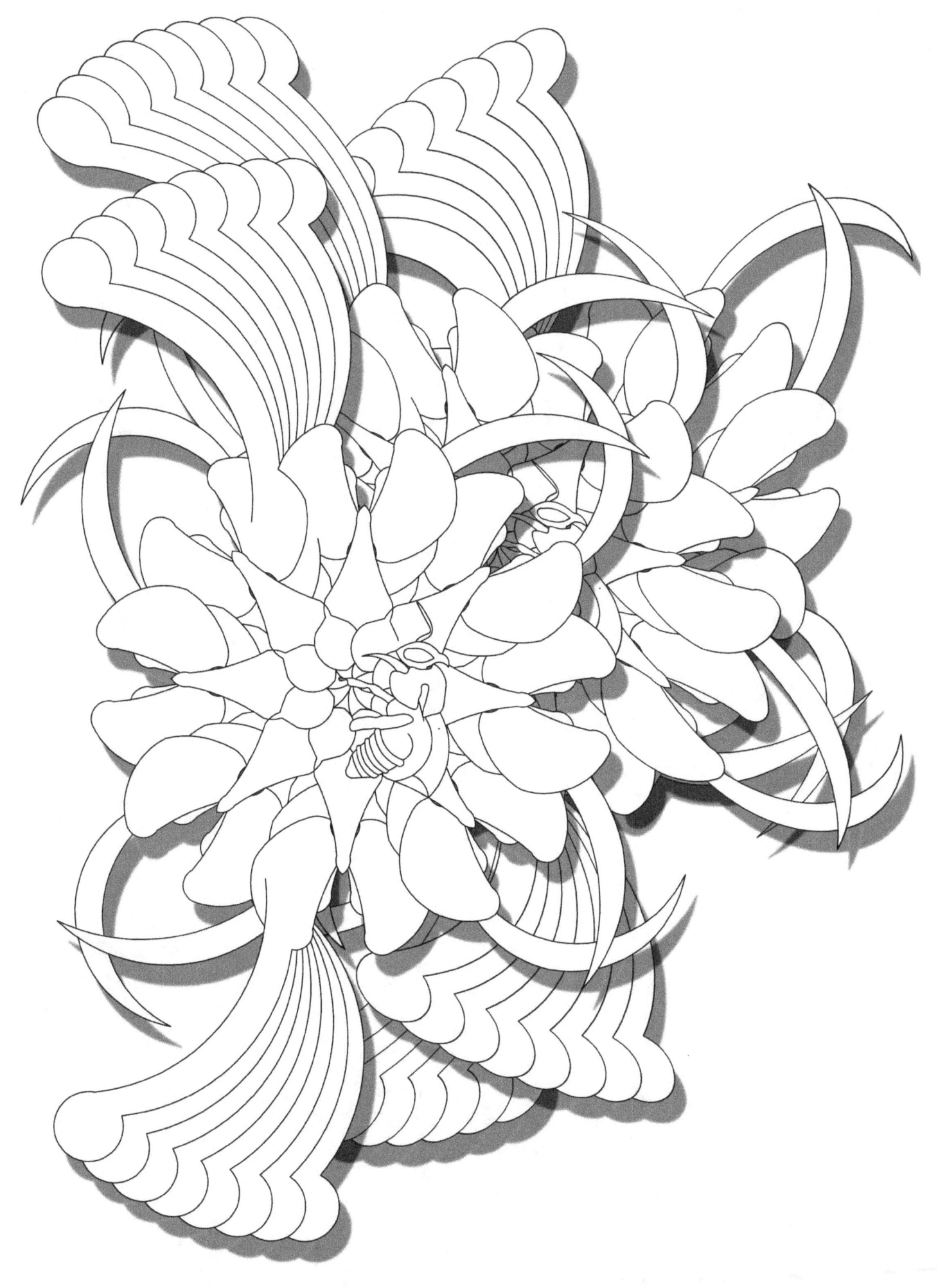

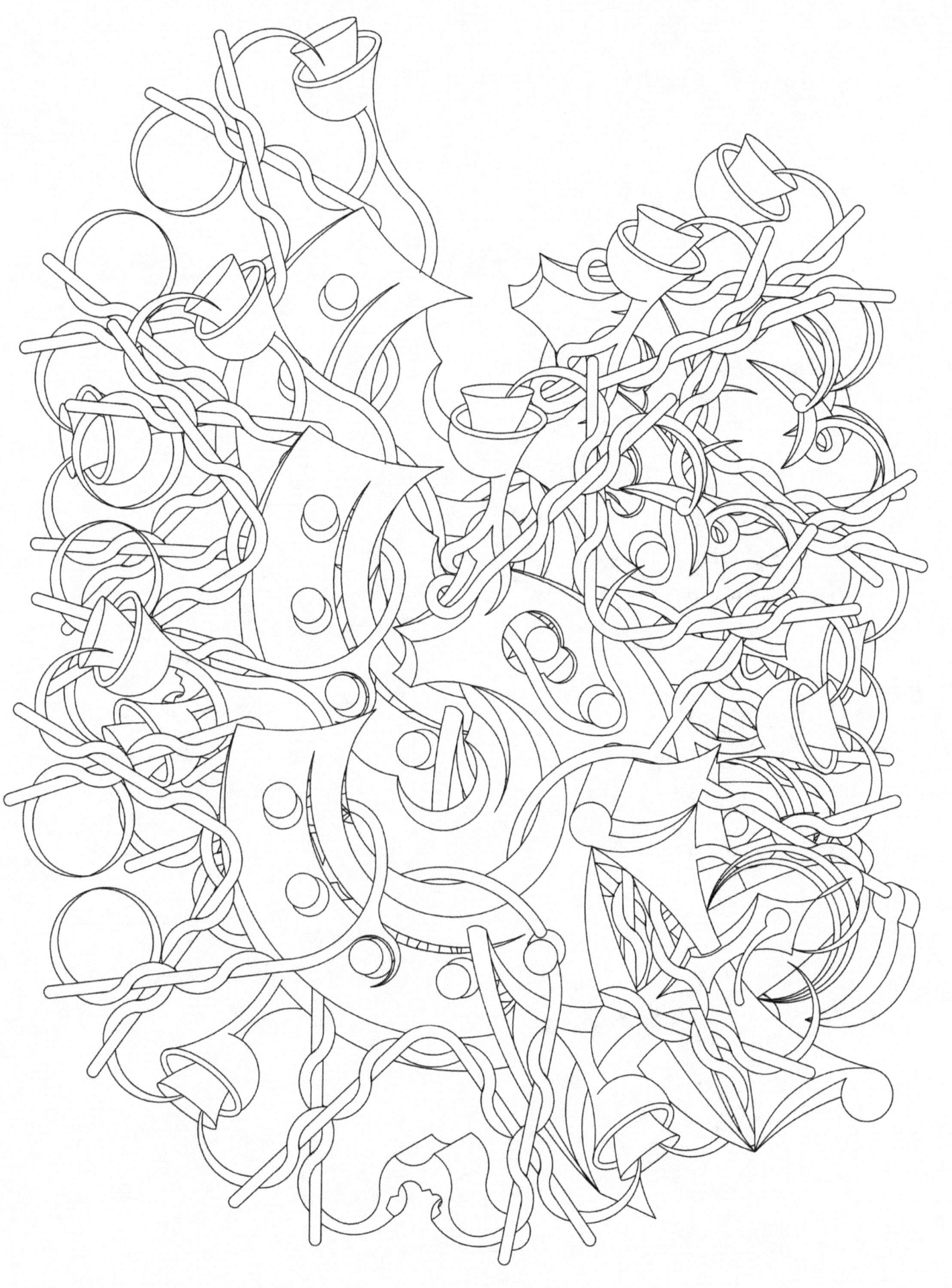

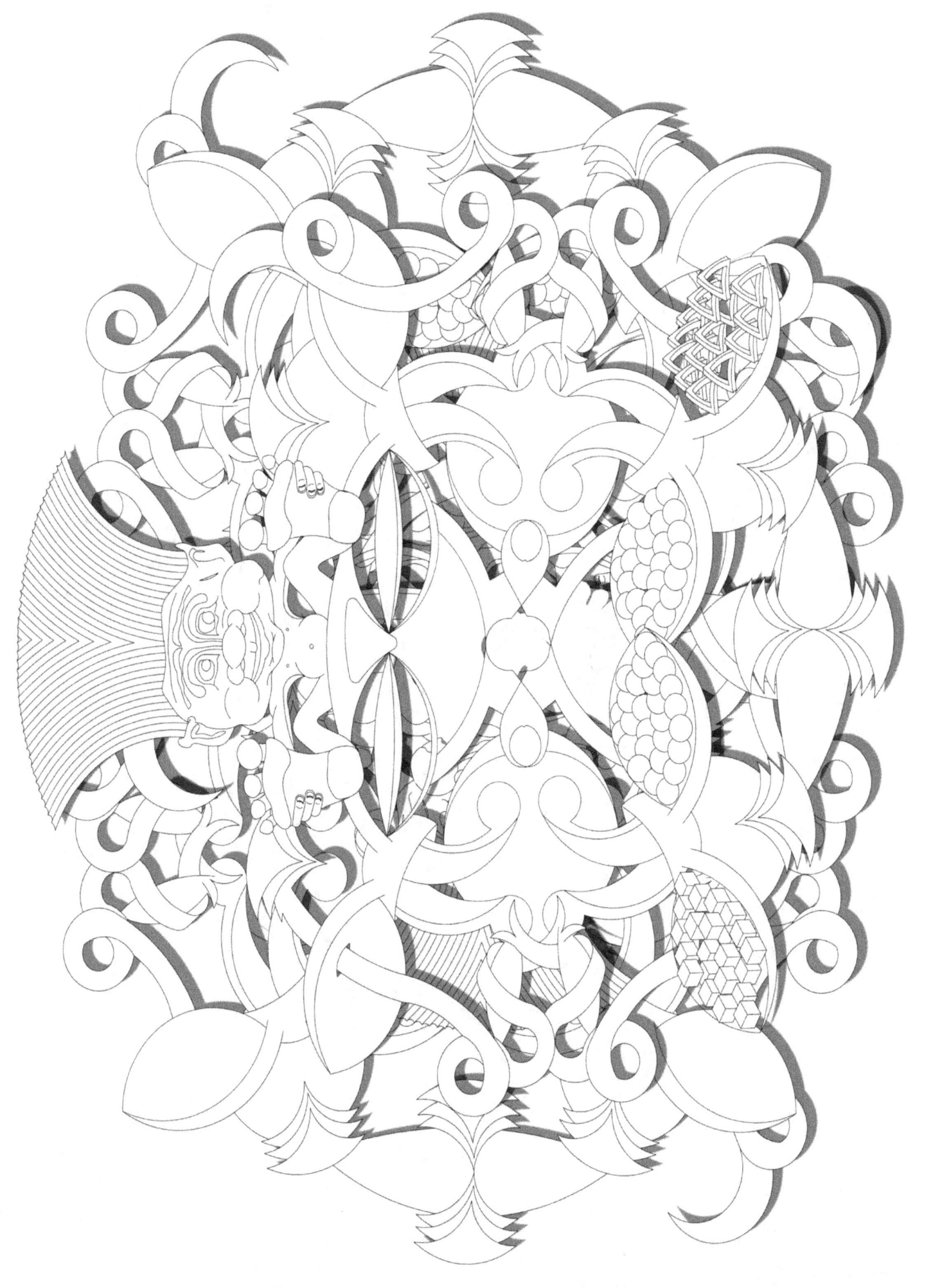

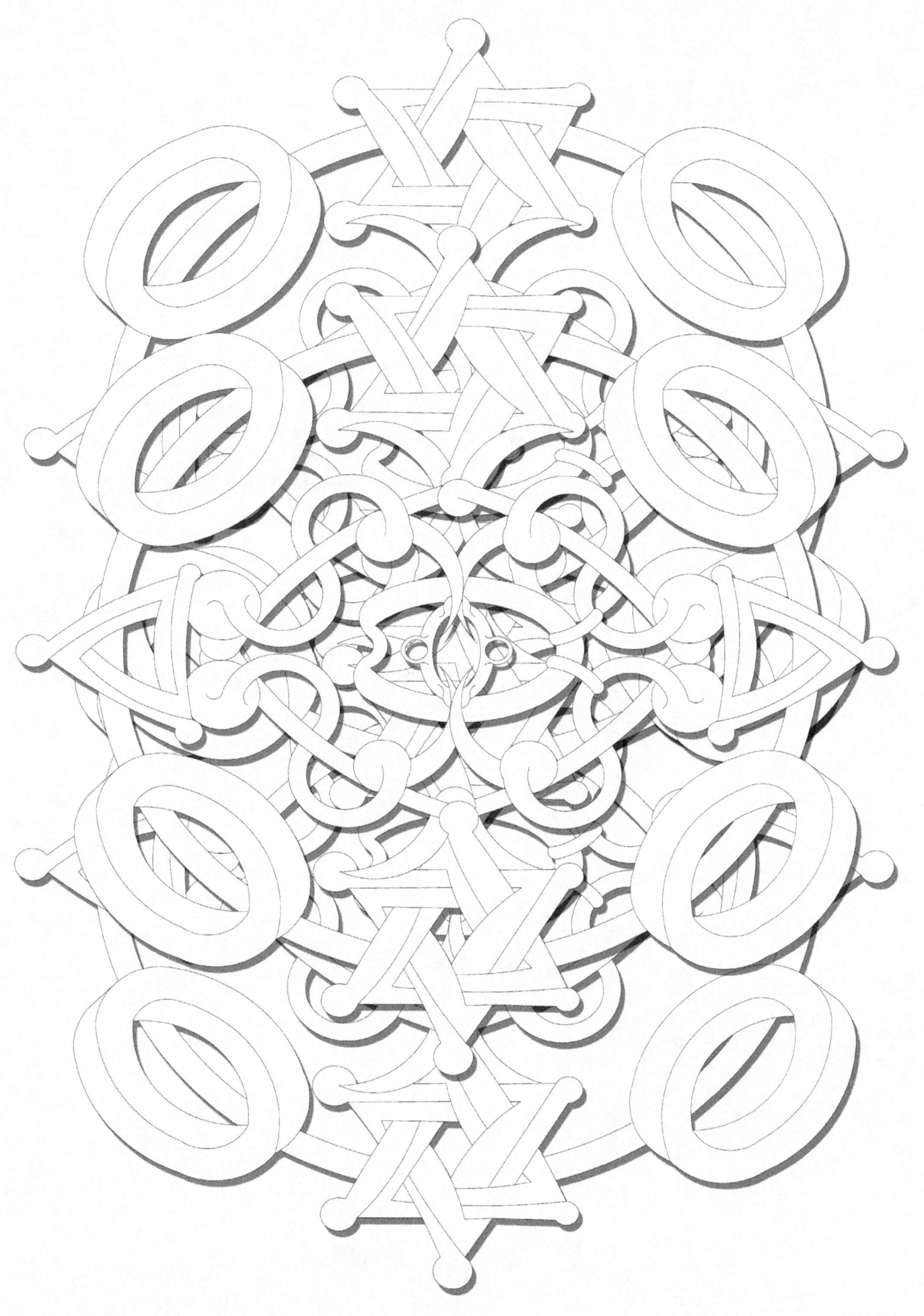

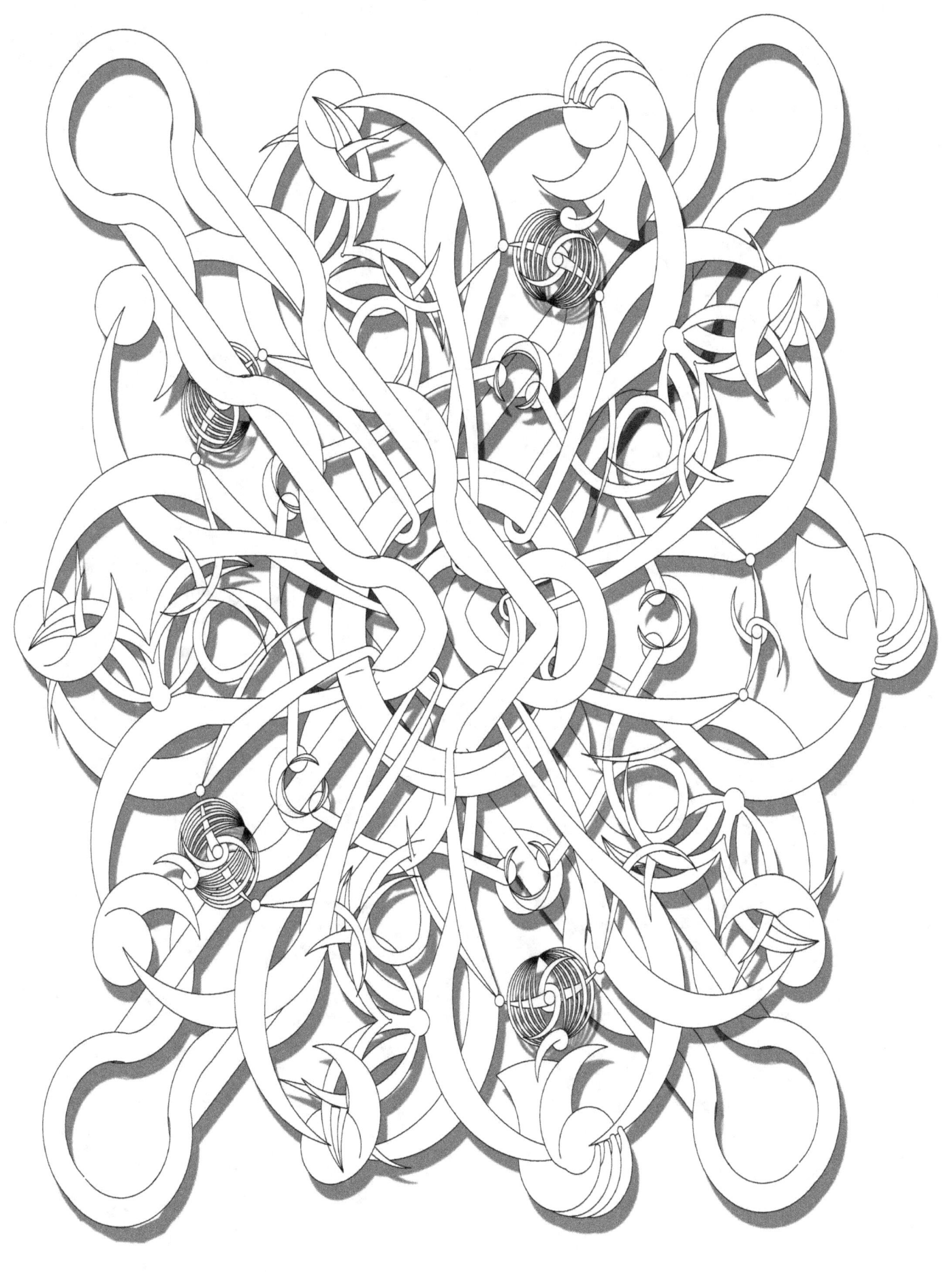

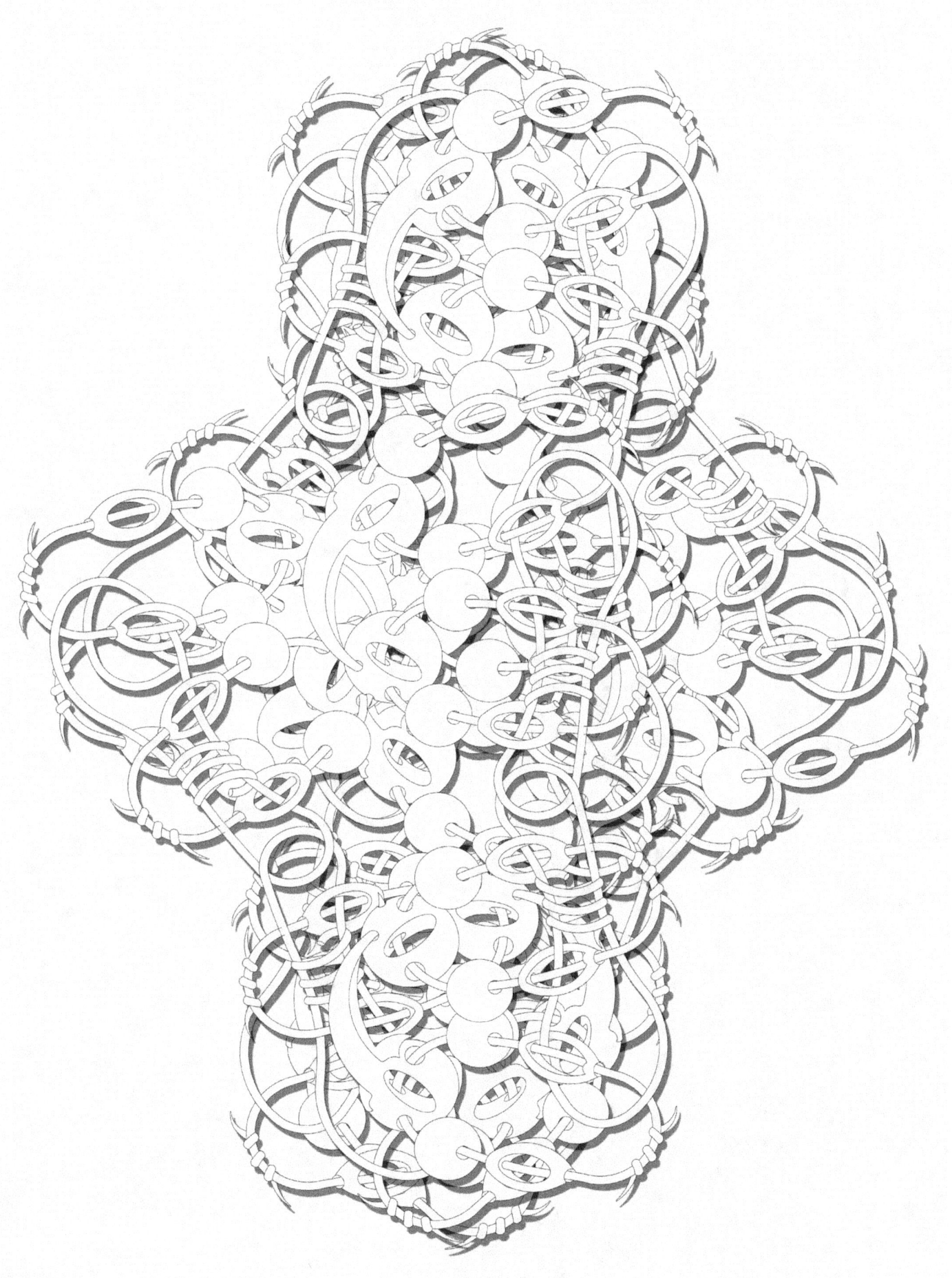

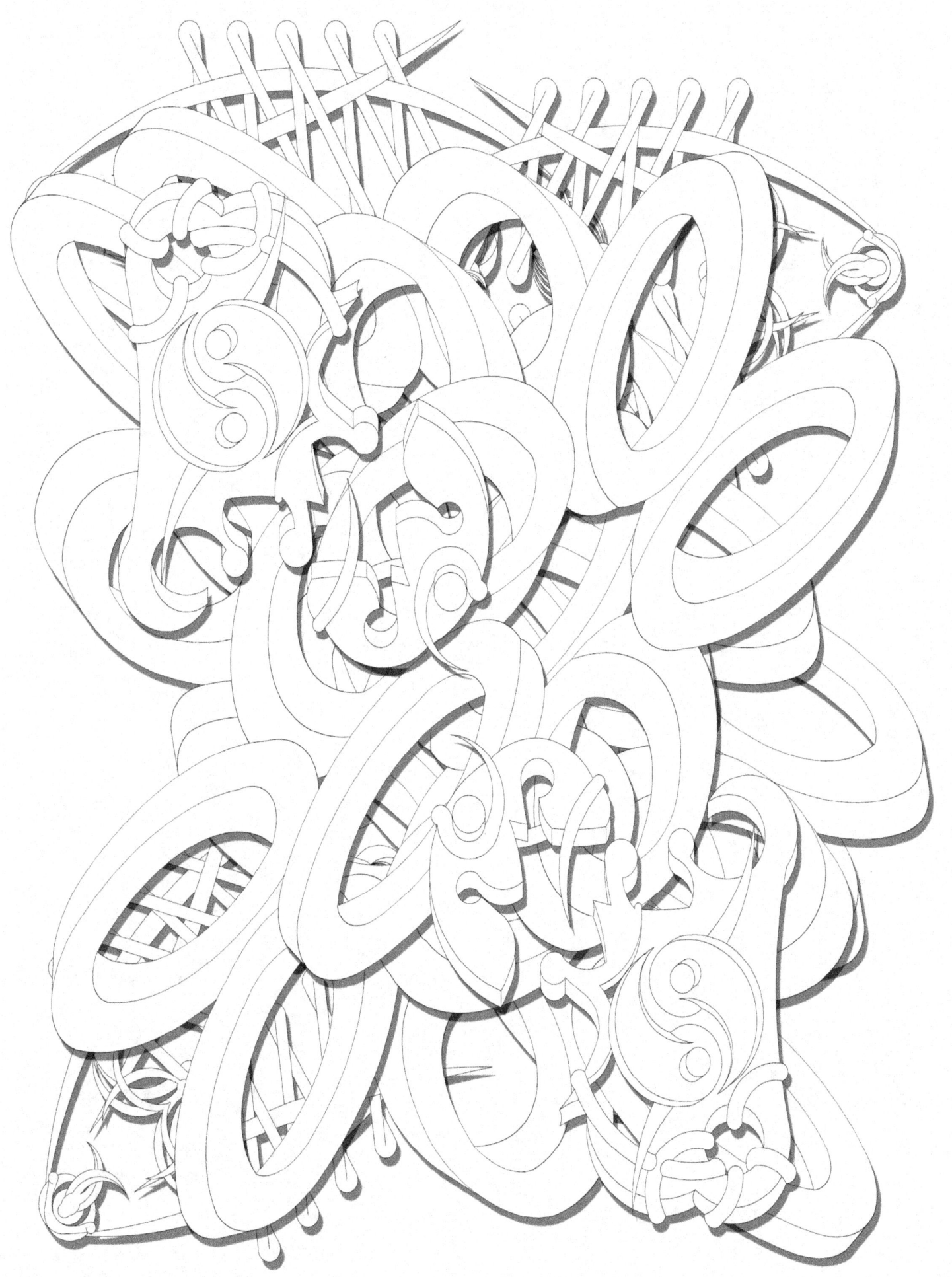

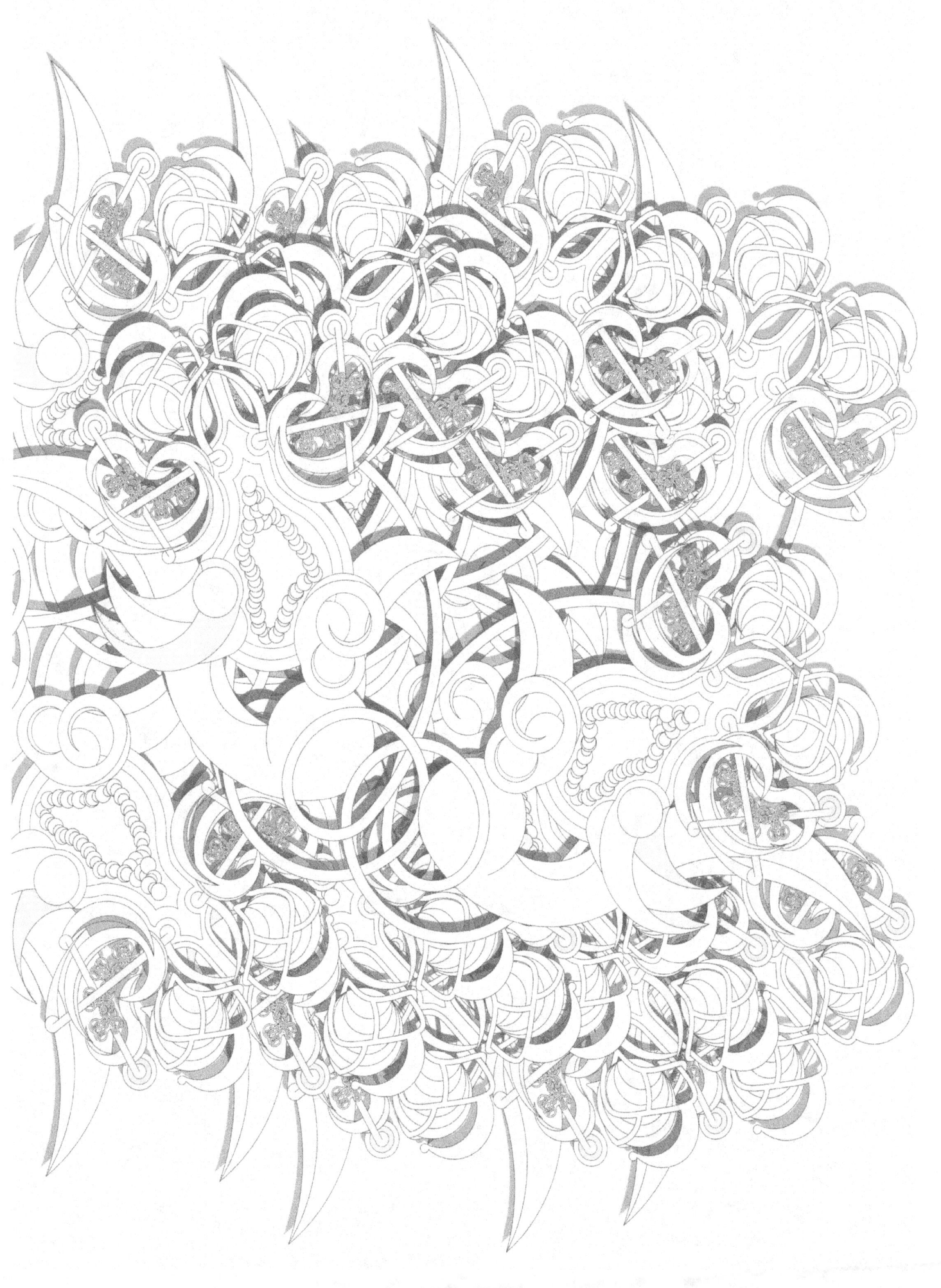

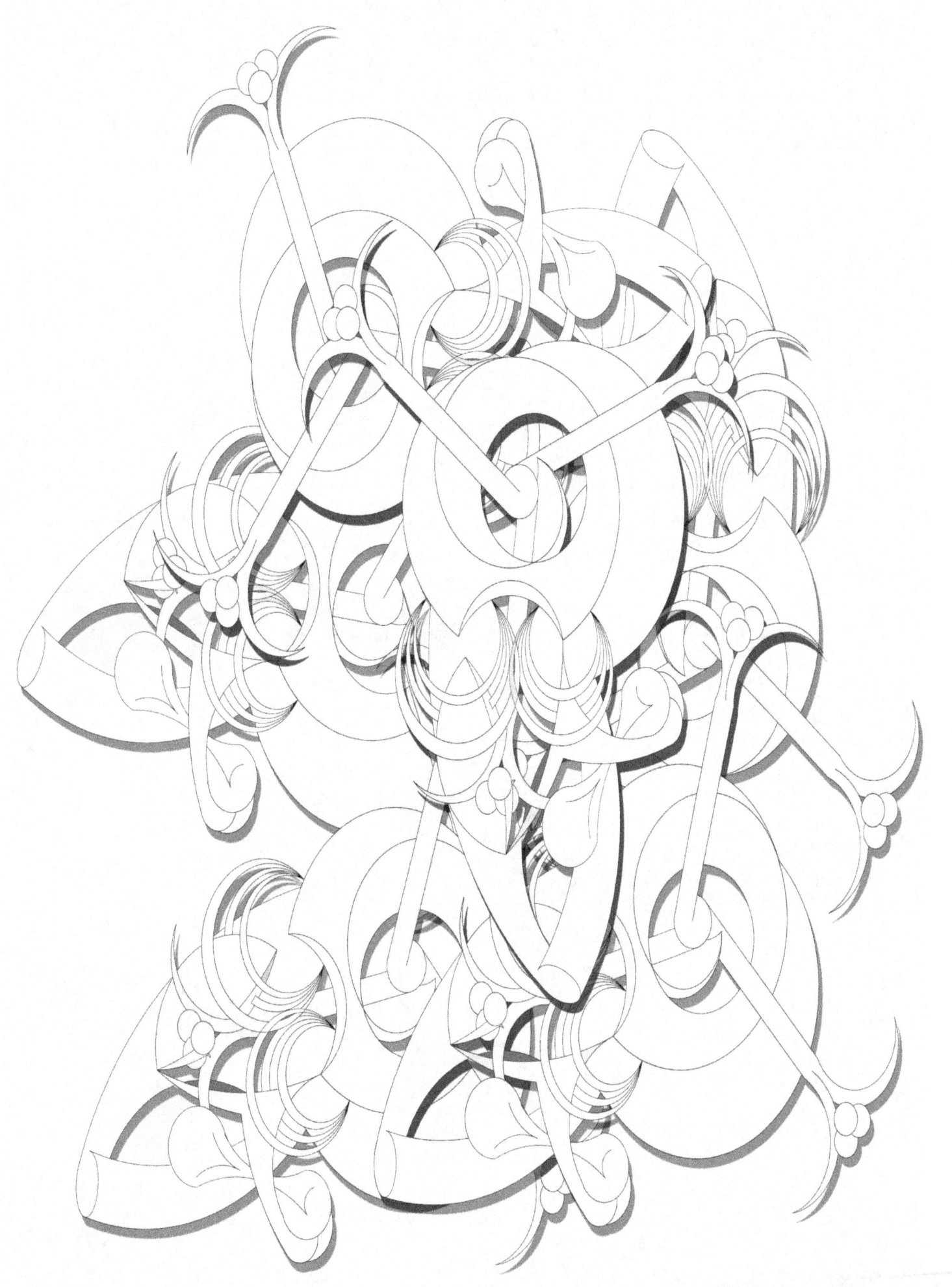

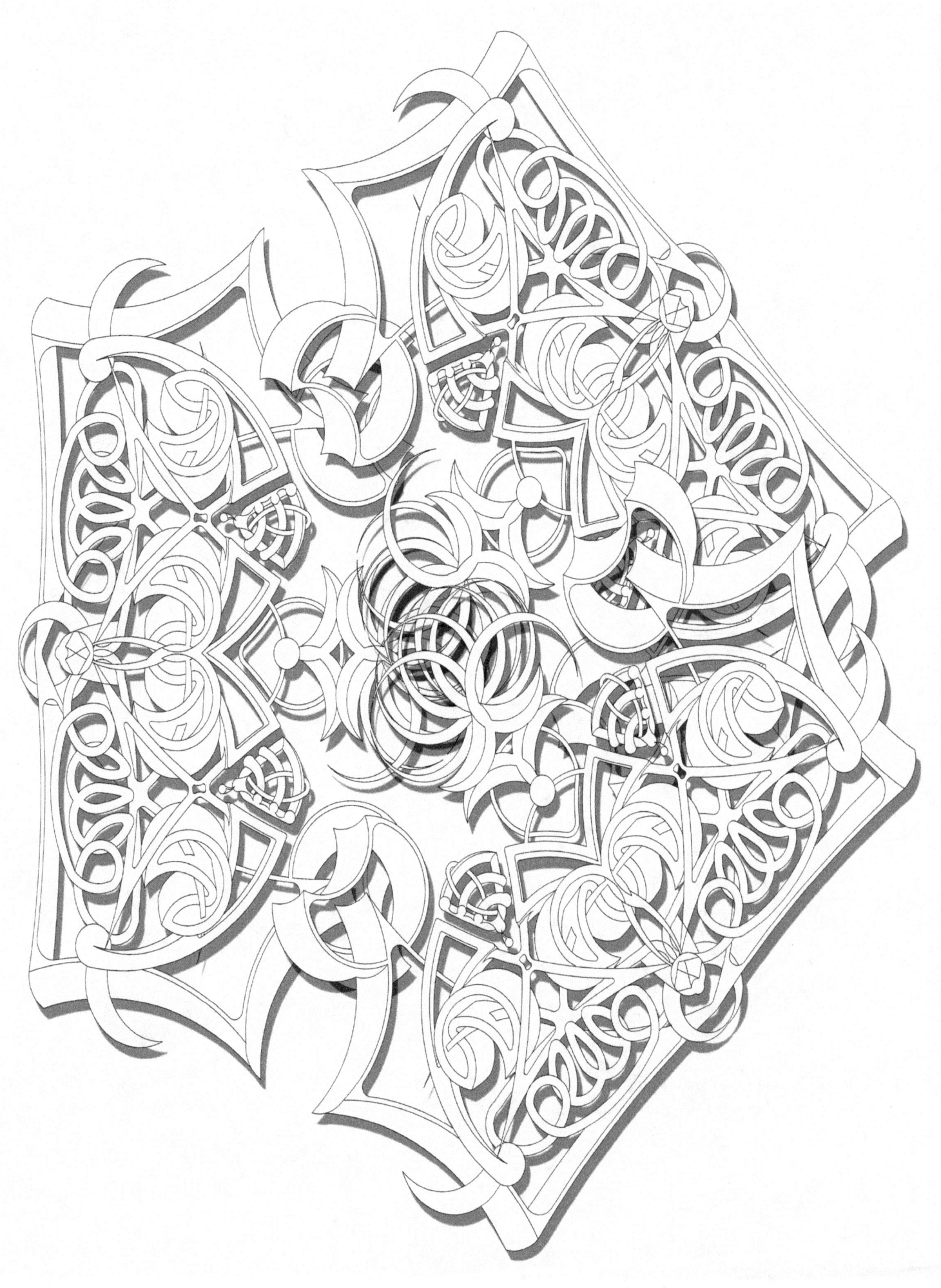

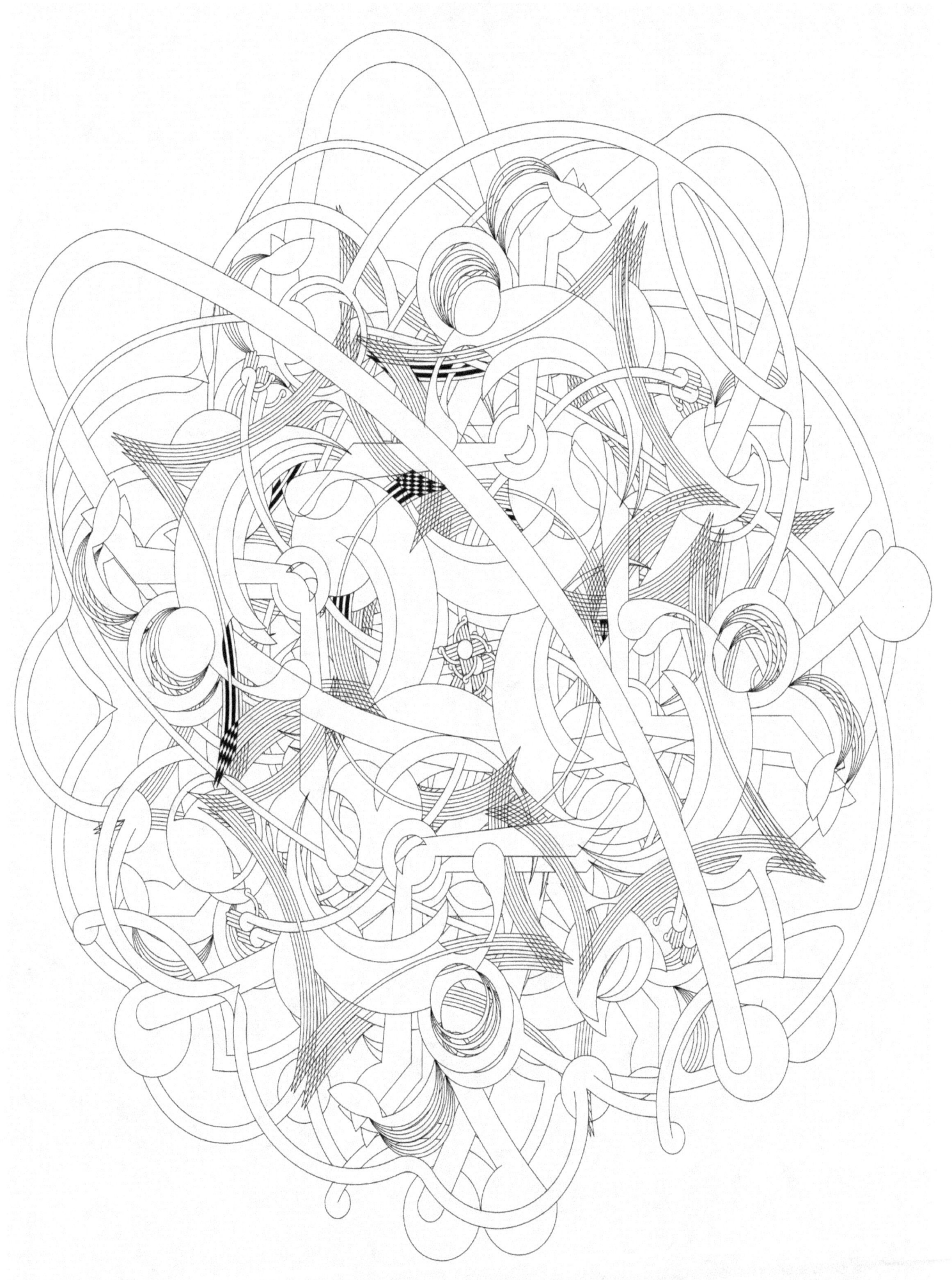

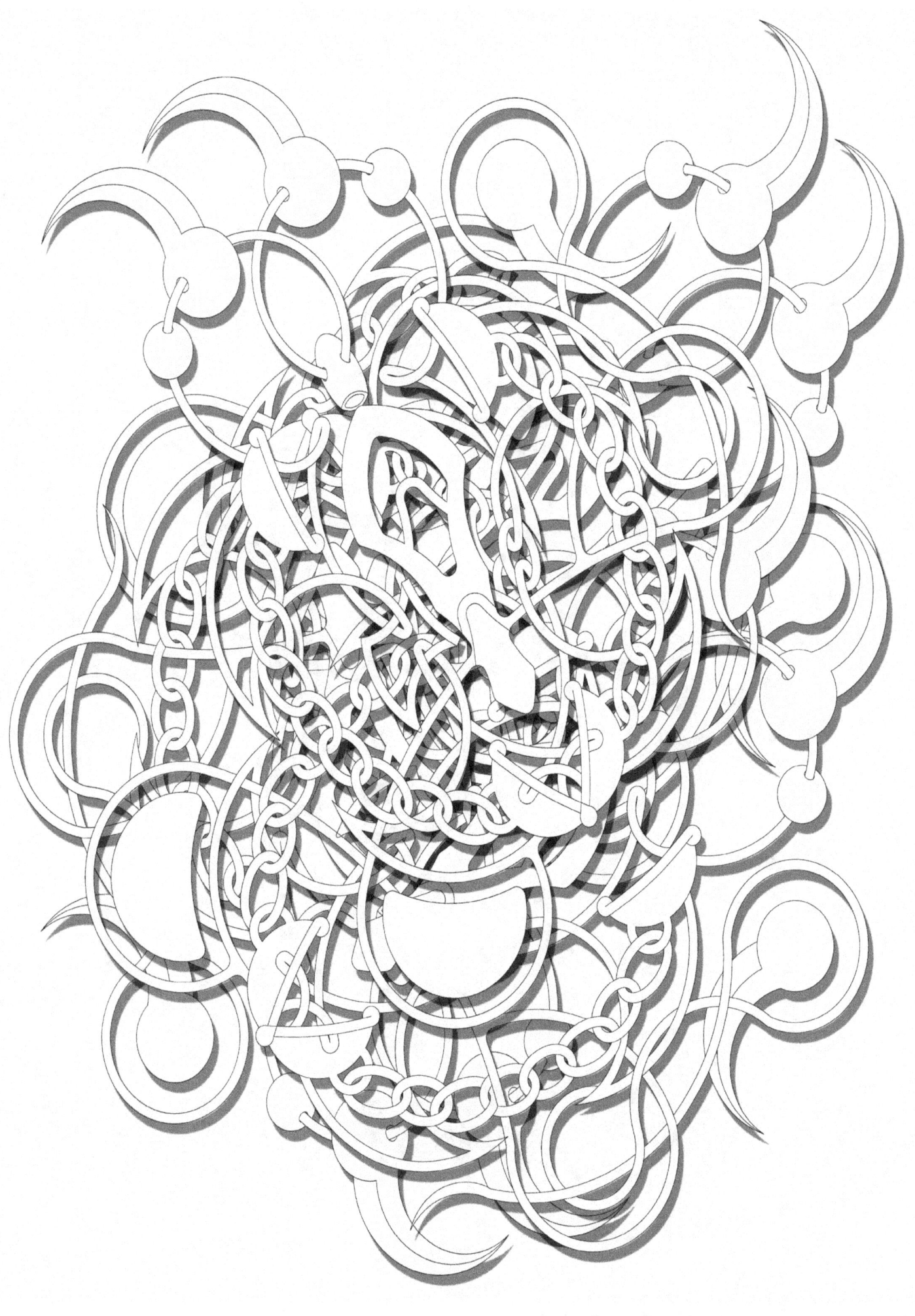

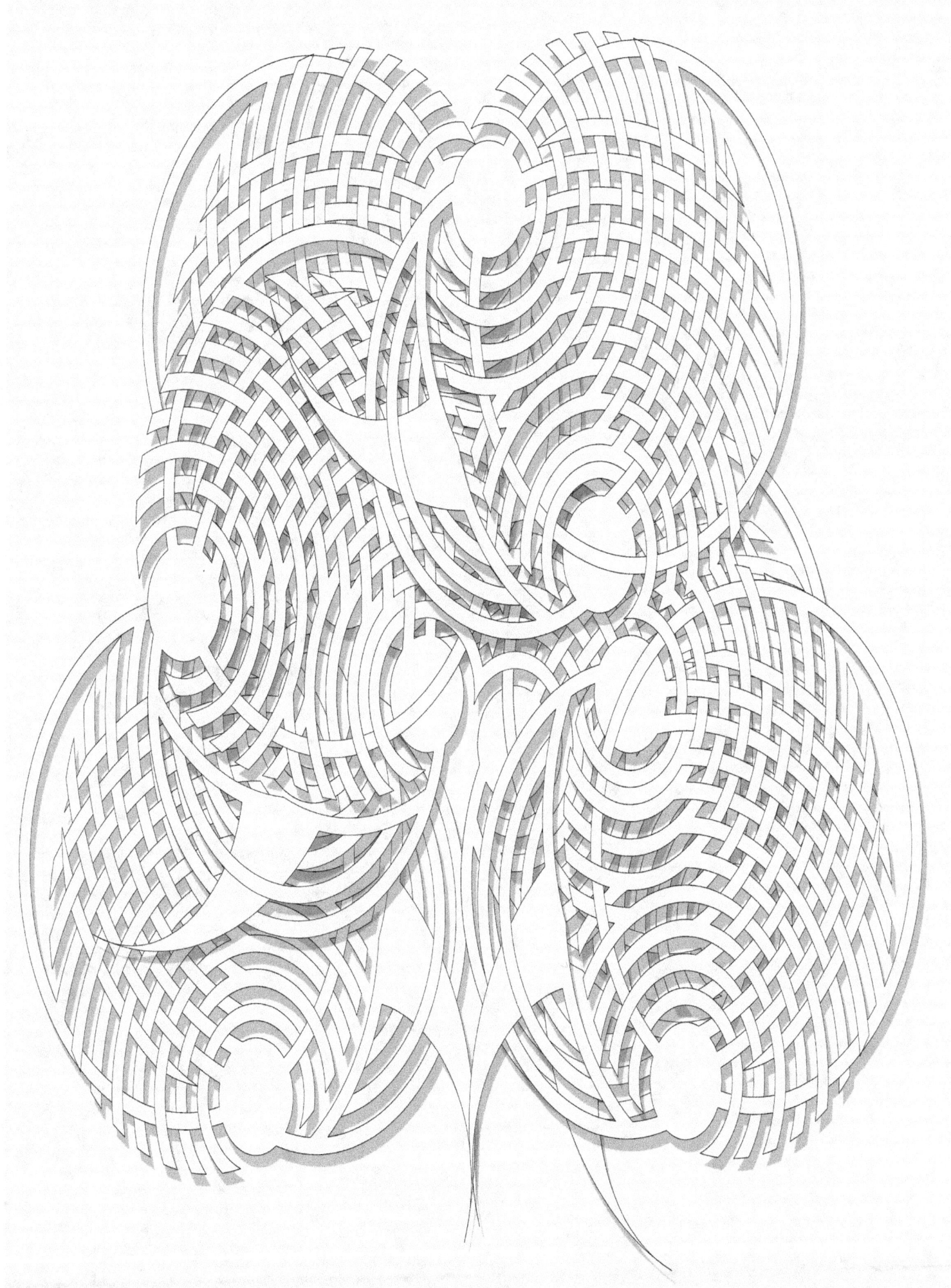

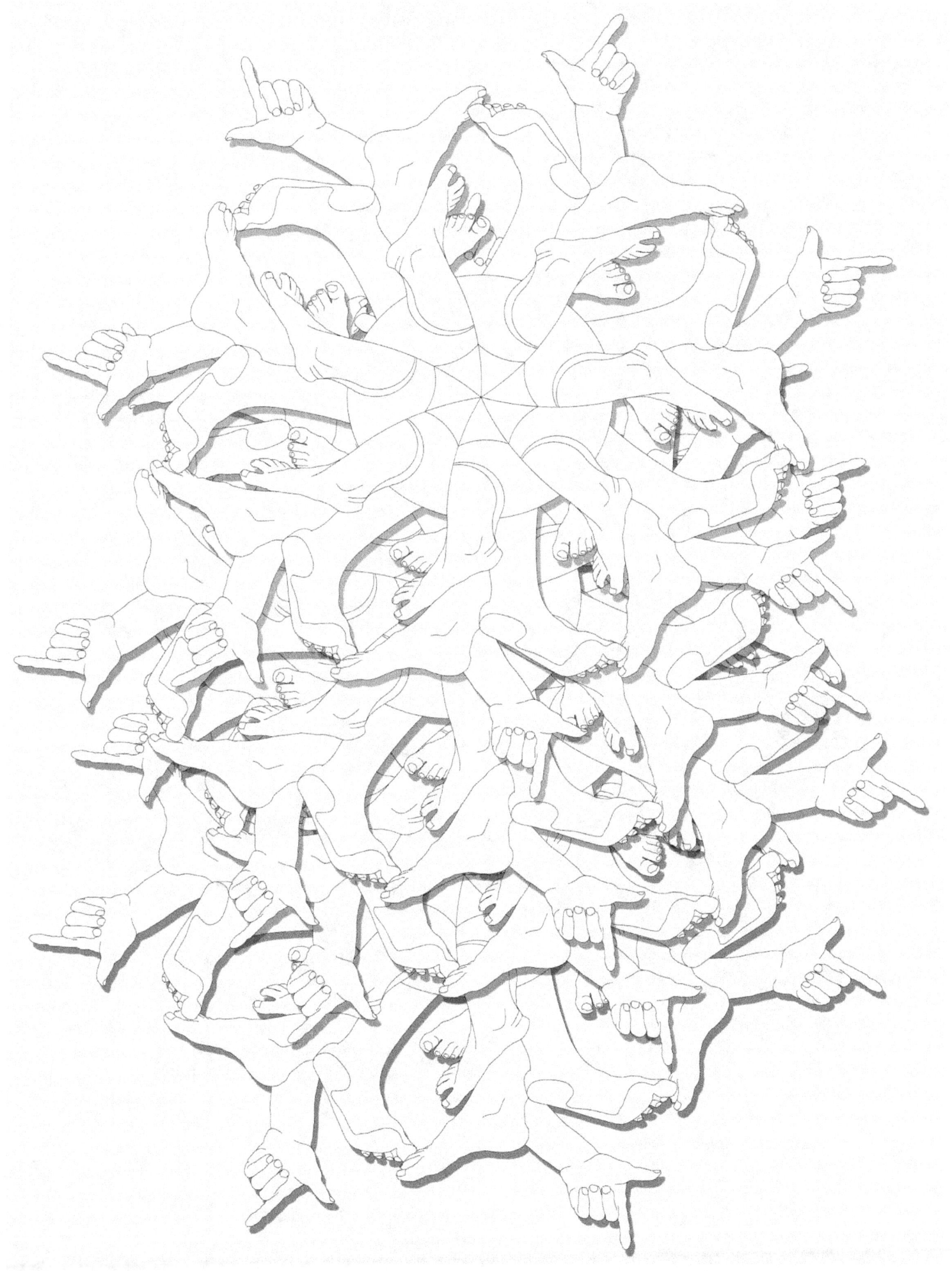

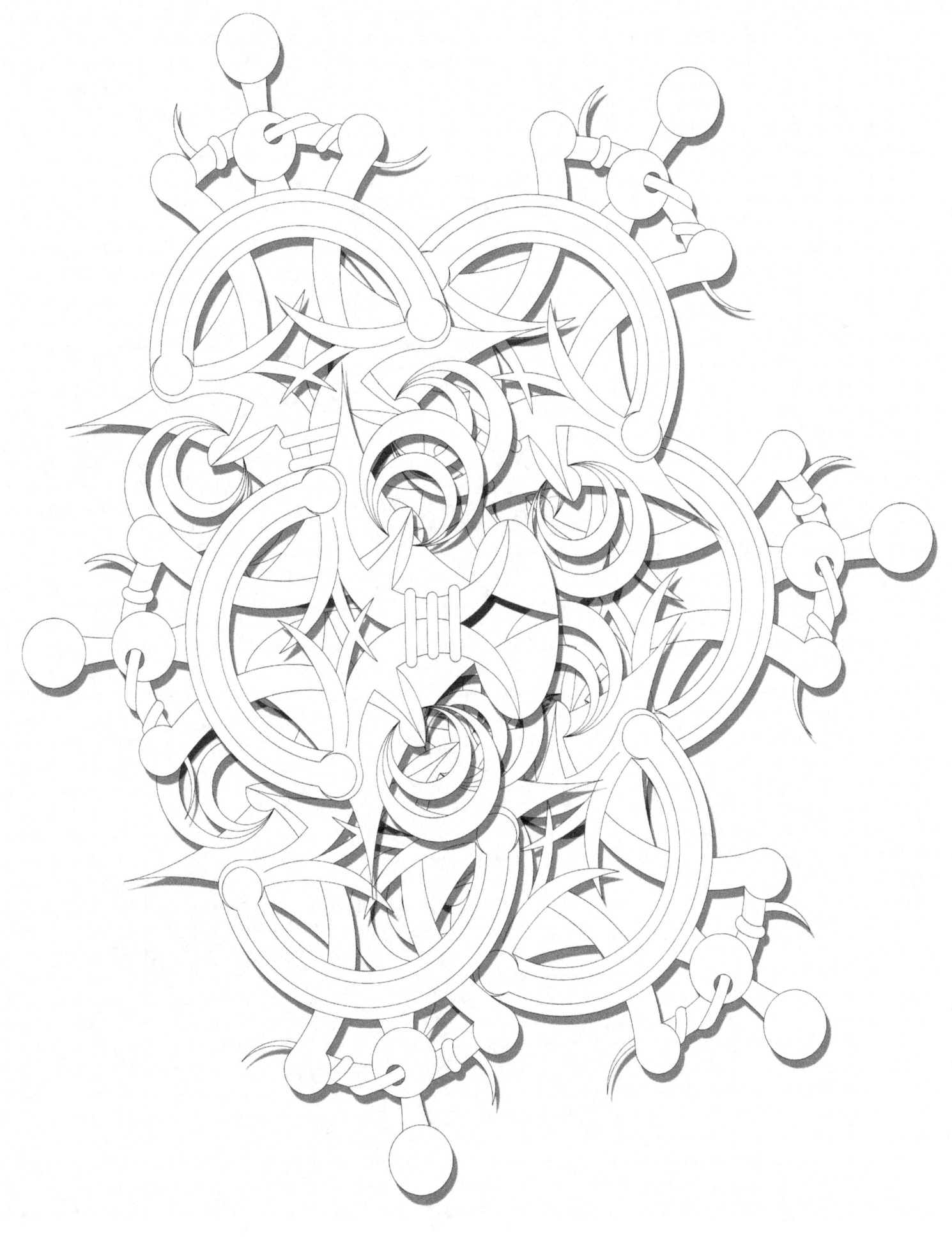

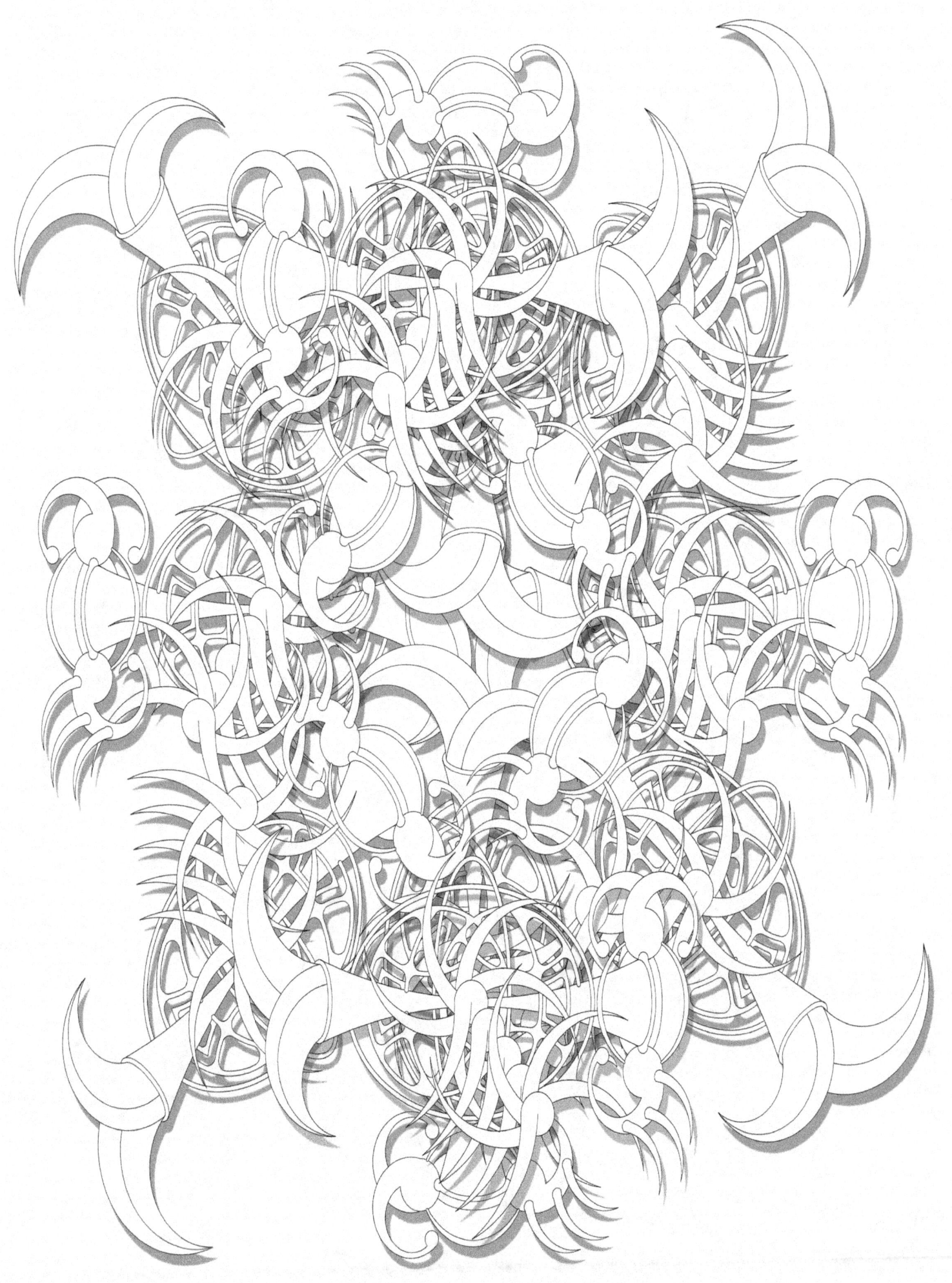

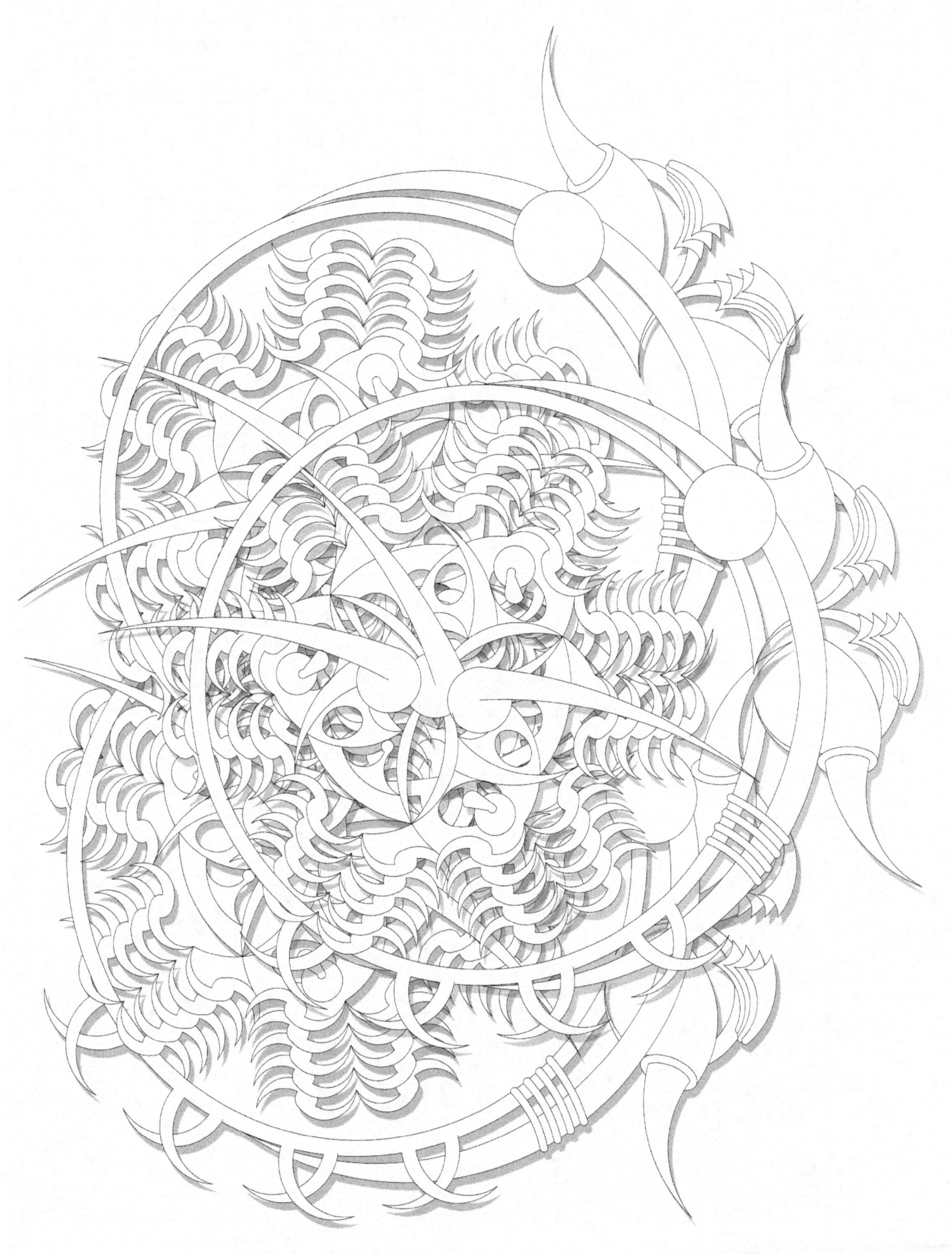

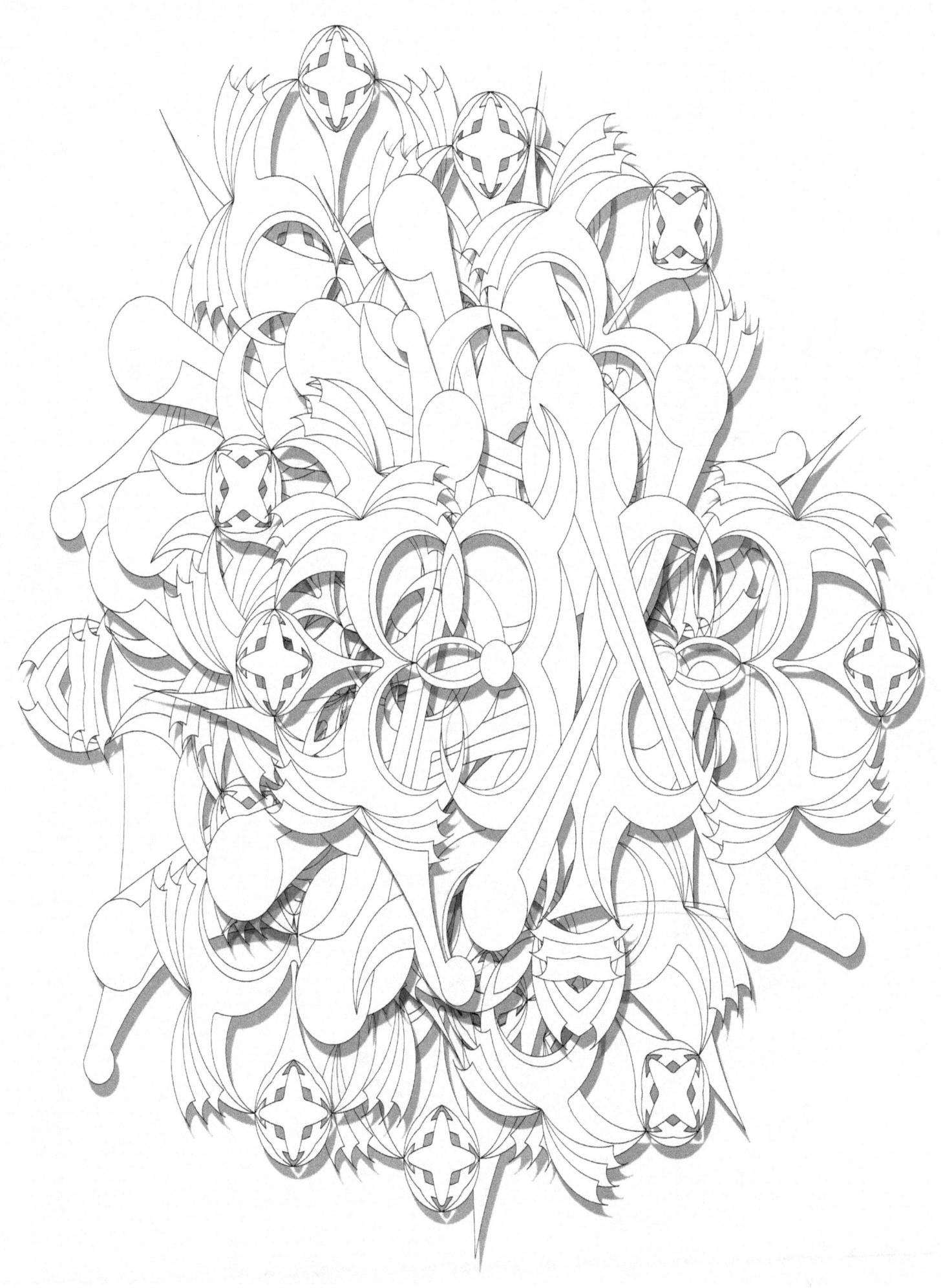

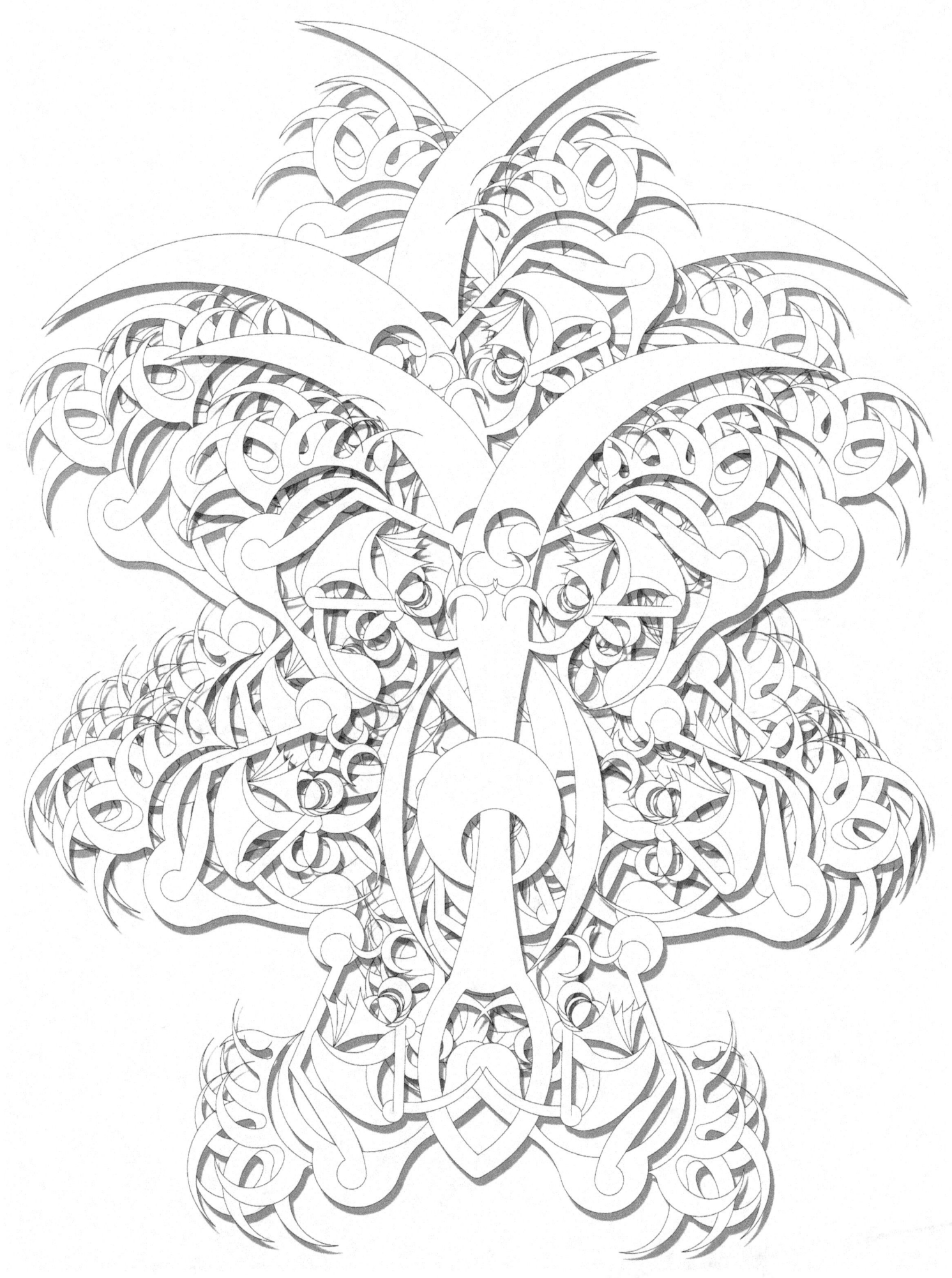

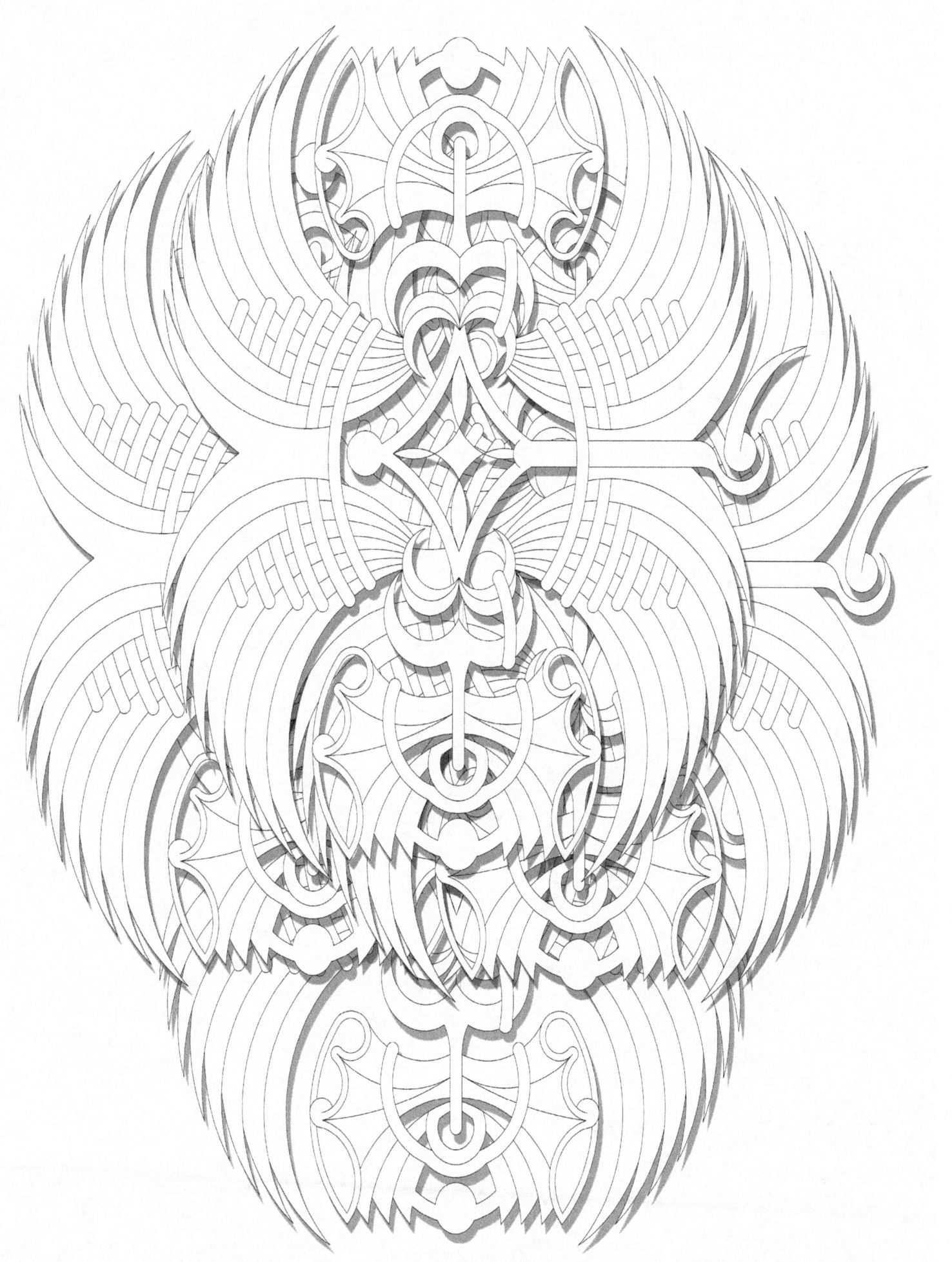

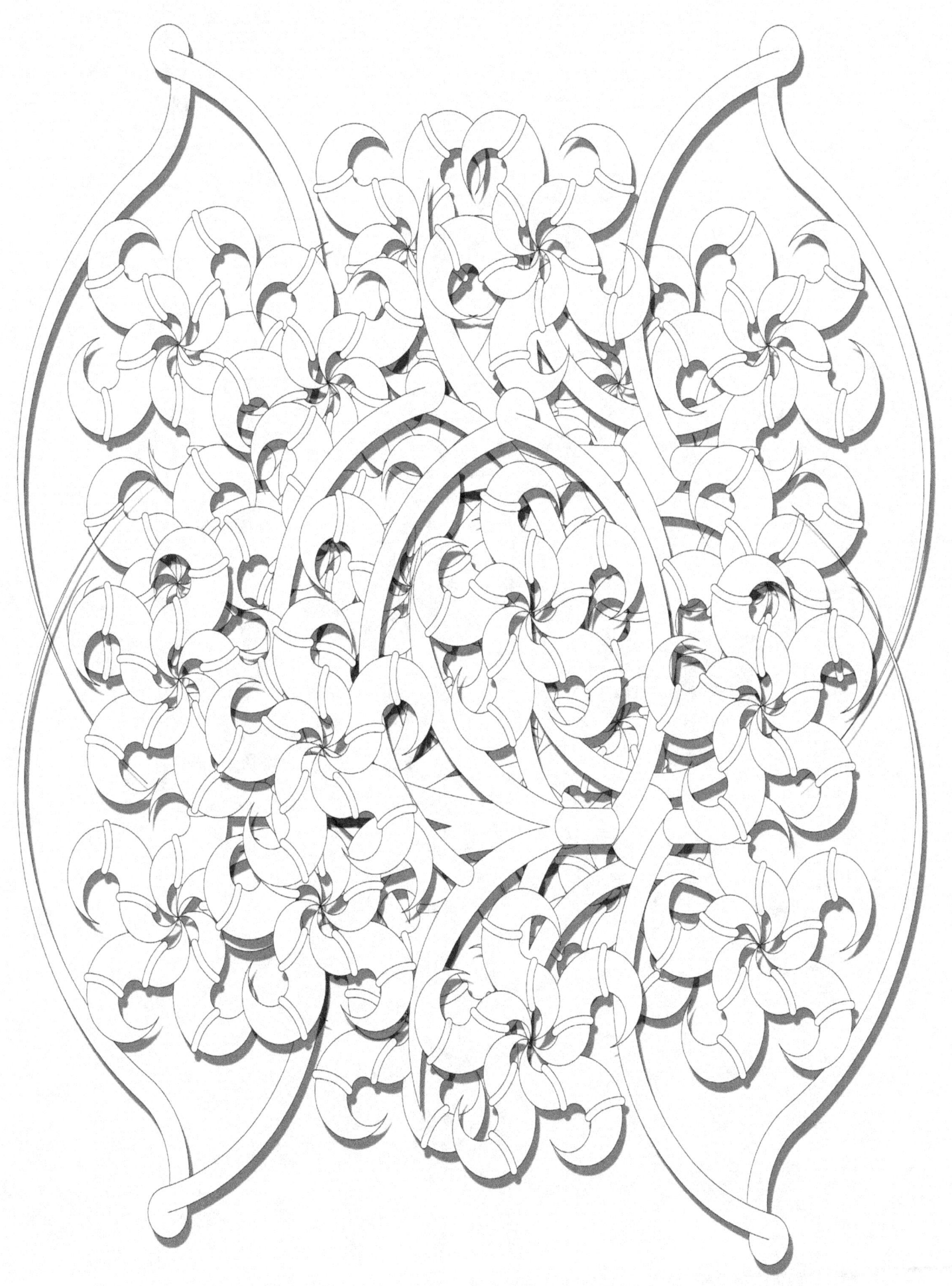

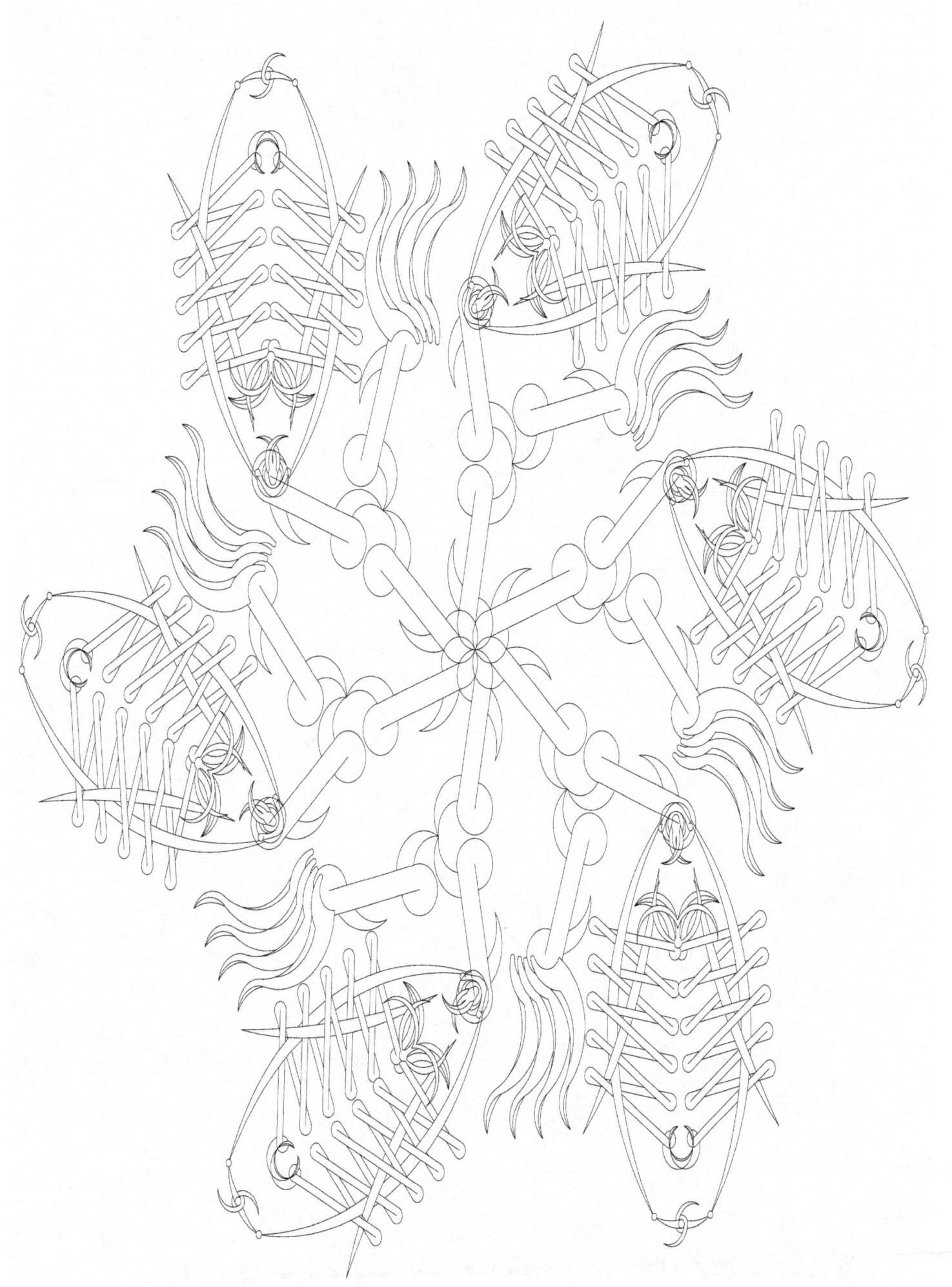

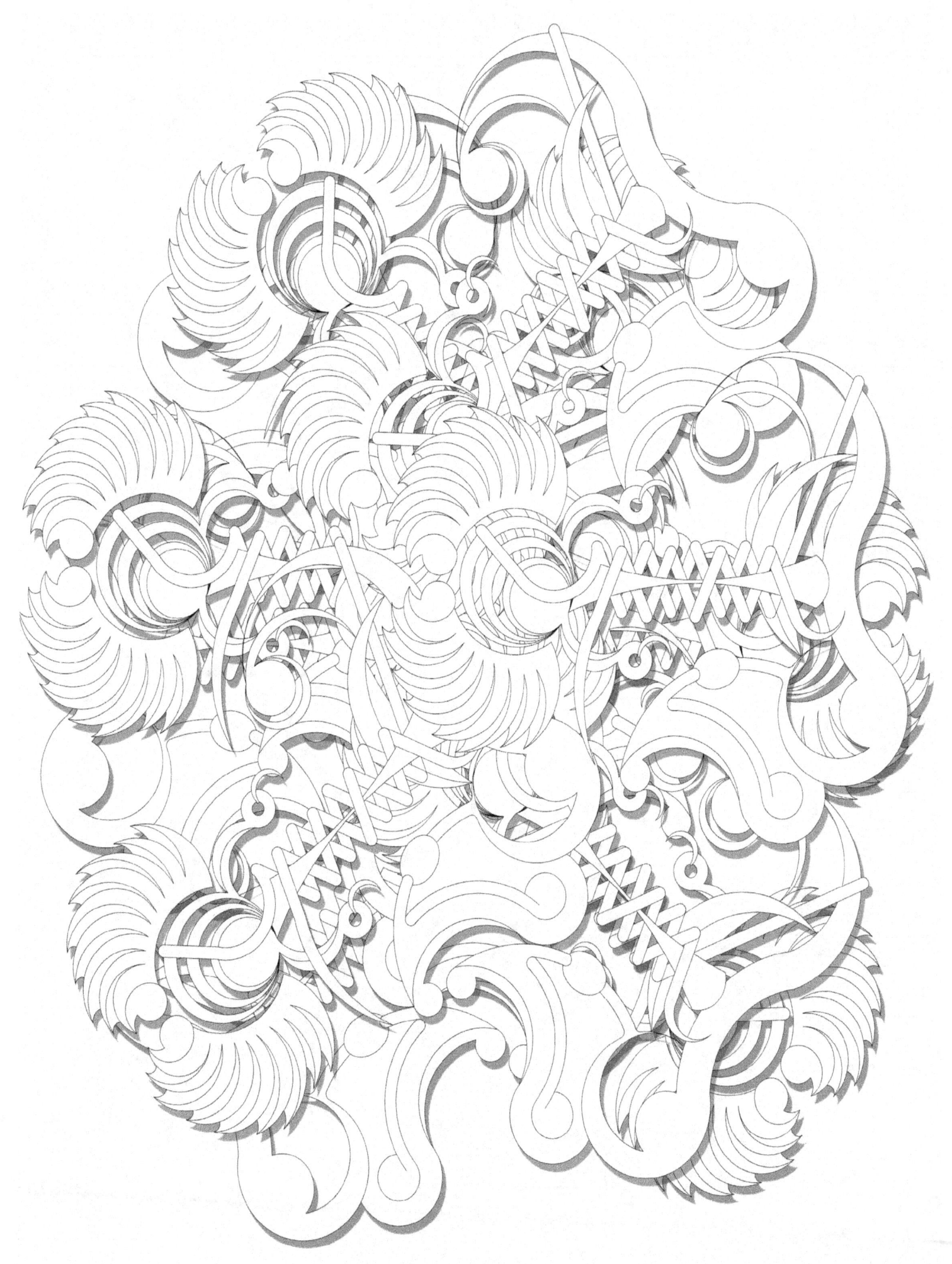

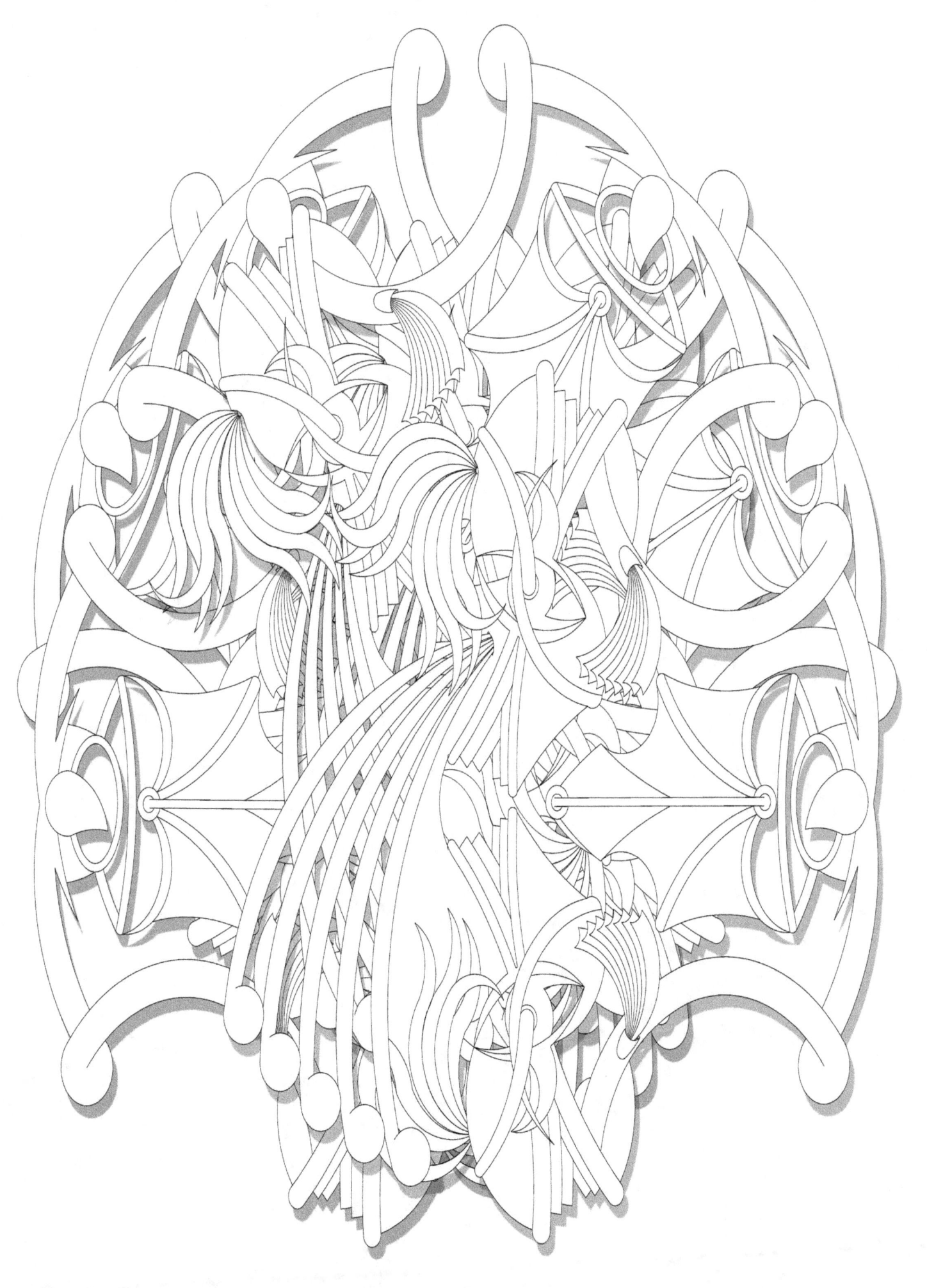

www.ingramcontent.com/pod-product-compliance
Lightning Source LLC
Chambersburg PA
CBHW081201180526
45170CB00006B/2185